R E S E R V A T I O N X

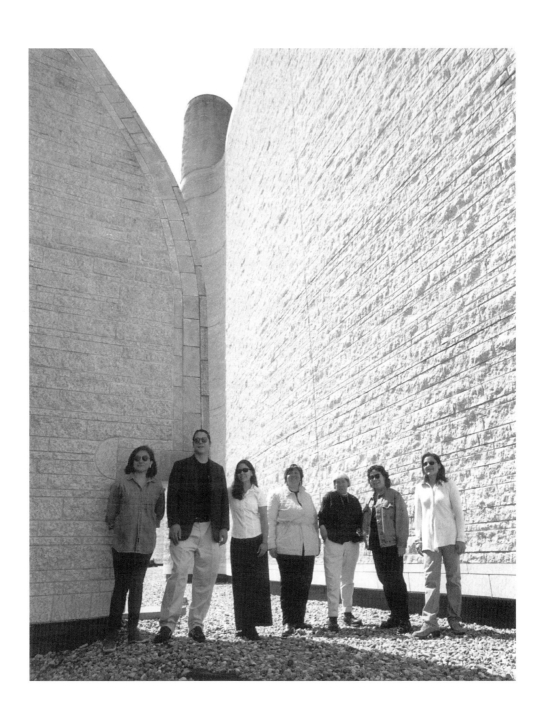

RESERVATION X

EDITED BY

GERALD McMASTER

GOOSE LANE EDITIONS AND
CANADIAN MUSEUM OF CIVILIZATION

Published by Goose Lane Editions and the Canadian Museum of Civilization, 1998, with the assistance of the Canada Council, the Department of Canadian Heritage, and the New Brunswick Department of Municipalities, Culture and Housing.

Edited by Laurel Boone and Marcia Rodríguez.
Canadian Museum of Civilization co-ordination by Anne Malépart.
Frontispiece: Nora Naranjo-Morse, Mateo Romero, Marianne Nicolson, Jolene Rickard,
 C. Maxx Stevens, Shelley Niro, Mary Longman. Photograph by Harry Foster.
Installation photographs by Harry Foster unless otherwise noted.
X graphic courtesy of Victory Inc.
Book design by Julie Scriver.
Printed in Canada by Friesens Book Division.
10 9 8 7 6 5 4 3 2 1

Canadian Cataloguing in Publication Data

McMaster, Gerald R., 1953-

 Reservation X

 Catalogue of an exhibition originally held in the First Peoples Hall of the Canadian Museum of
 Civilization, curated by Gerald McMaster.
 Includes bibliographical references.
 Co-published by the Canadian Museum of Civilization.
 ISBN 0-86492-250-7

1. Indian art — North America — exhibitions.
2. Installations (Art) — North America — Exhibitions. I. Canadian Museum of Civilization.

N6494.I56M35 1998 704.03'97'0074 C98-950180-9

Goose Lane Editions
469 King Street
Fredericton, New Brunswick
CANADA E3B 1E5

CANADIAN MUSEUM MUSÉE CANADIEN
OF CIVILIZATION DES CIVILISATIONS
100 Laurier Street
PO Box 3100, Station B
Hull, Quebec
CANADA J8X 4H2

CONTENTS

THE ESSAYS

MARY LONGMAN: STRATA AND ROUTES

ART AND COMMUNITY

I am delighted to introduce *Reservation X: The Power of Place in Aboriginal Contemporary Art*. Unique in several ways, this project became possible thanks to seven extremely talented artists — Mary Longman, Nora Naranjo-Morse, Marianne Nicolson, C. Maxx Stevens, Shelley Niro, Jolene Rickard, and Mateo Romero — who have generously agreed to share their ideas about art and community.

Reservation X was inspired by the fact that more and more aboriginal artists have chosen to move back to the reserve or reservation. This recent trend has led to serious reflection among these artists about the meaning of community. Although the seven artists presented here view community in different ways, all recognize their affinity to an aboriginal identity. For some, the artist's presence is important for articulating cultural identity; others look on artistic creations as truly individual and private forms of expression.

Edited by Gerald McMaster, *Reservation X: The Power of Place in Aboriginal Contemporary Art* seeks to help us understand the breadth and diversity of aboriginal identity as well as the extent of the power of place on us all. It offers a new perspective on aboriginal contemporary art and opens the door to recent developments in the exchange between artists, writers, supporters of contemporary art, and the public.

George F. MacDonald, President and CEO
Canadian Museum of Civilization Corporation

THE CENTRALITY OF PLACE

To recognize the centrality of place in the indigenous cultures of this hemisphere is to understand one of the most defining elements of Indian life. Place determines who we are in that it establishes our relationship to everything around us. Our cultures, including our aesthetic productions, grow out of that relationship to place. I say relationship rather than "connection," because the latter's meaning seems too mechanical to express the rich intermesh between person and place in Native life. It is not simply a "connection to the land," but a multidimensional interdependence between place and community that shapes the way we live and think.

The locus of Native community life in the modern era has been the reservation (or in Canada, the reserve). But community life "on the rez" has grown more complex as the impact of mainstream society has intensified. This process has prompted the challenging and creative investigation of indigenous communities you will encounter in *Reservation X*.

At the National Museum of the American Indian, we are very pleased to host the New York showing of *Reservation X* at the George Gustav Heye Center. Developed by our friends at the Canadian Museum of Civilization, the exhibition and book draw upon the powerful talents and insights of some of our most gifted artists and writers in the United States and Canada. They help us to see more clearly how the forces of change intersect with the robust strengths of tradition. They enable us to get a surer grip on the sometimes elusive question of Native identity.

In his essay, Paul Chaat Smith (Comanche) writes, "There was genuine doubt about whether we were going to be around or not, and if we were, whether we could cut it or not. Those doubts have vanished." *Reservation X* brings us the heartening affirmation that it is the doubts about Indians, rather than the Indians themselves, that are vanishing.

W. Richard West, Director
National Museum of the American Indian
Southern Cheyenne
Member of the Cheyenne and Arapaho Tribes
of Oklahoma

COMMUNITY AS CONTEXT

The seven artists featured in *Reservation X* are part of a growing group inspired by the Native art movement of the last forty years. Their work reflects a commitment to self-determination, individual visions, and new storytelling devices. Cars, planes, and cellular phones define these artists' lives today as much as pots, baskets, and beadwork. For decades, Native artists expressed themselves in media and subject matter designed to be "acceptable" to a mainly non-Native audience. This changed during the 1950s and 1960s, when many Indian artists, such as the sculptor Allan Houser, began to utilize media and forms that previously had not been defined as "Native" by the mainstream marketplace. The establishment of the Institute of American Indian Arts in Santa Fe, New Mexico, in 1962 further empowered and encouraged a new generation of artists to approach art in any manner they could imagine. This generation revolutionized the staid marketplace for Native art by radically changing preconceived notions of what constituted "Indian" art.

Contemporary indigenous artists continue to challenge non-Native definitions and assumptions of what is traditional, spiritual, environmental — indeed, what is Native. The artists of *Reservation X*, influenced by urban and rural environments and Native and non-Native cultures, explore concepts of community and cultural identity through innovative work that reflects their distinct personal and artistic backgrounds, as well as their individual ideas about community, however it may be defined — reservation, reserve, rural, urban, or the hundreds of possibilities in between.

Today, the indigenous imagination may envision community as a specific village, a visionary landscape, or even a way to ensure the continuity of cultural tradition. As Nora Naranjo-Morse (Tewa, Santa Clara Pueblo) states, "We're at this very important place. We have the opportunity to begin thinking communally, at the end of this millennium, about what is best for our people. . . . That's part of what the community is to me now." Replete with inventive techniques, new media, and visionary power, *Reservation X* offers to both Native and non-Native viewers a novel perspective on community and place that provides unexpected insight into the diversity and vitality of Native art today.

**Bruce Bernstein, Assistant Director for
Cultural Resources
National Museum of the American Indian**

ACKNOWLEDGMENTS

Organizing a project like *Reservation X* requires collaboration and understanding. Like its governing idea, community, everyone worked together, which made the project a pleasure. From the beginning I was encouraged by the management of the Canadian Museum of Civilization, who gave me freedom and opportunity and made it easier to overcome difficult problems. Although the Museum has always supported projects with aboriginal communities, this one was somewhat different. *Reservation X* allowed the artists an important and critical voice in telling us who they were and where they came from; it gave the Museum and its audiences new ways with which to view community.

One benefit of publishing is that it provides an opportunity to publicly acknowledge all the contributors, not only to this volume but to the entire project. Arthur Renwick has been a loyal participant as co-curator from the project's inception, through its develop- ment, and to its final delivery.

As well, many members of the team, both the Museum staff and outside contractors, deserve recognition. Helen MacKinnon, Project Manager, joined us at the appropriate moment; Tracy Pritchard, Expographiq, created an inspiring space for the artists to work in; Daniel M. Lohnes, Victory Design, impressed everyone with his graphic design; Anne Malépart, Publishing Division, coordinated the production of this book; Odette Dumas and Rachael Duplisea, Communications, worked hard to bring attention to the project; Louis Robillard, Special Events, gave us Kashtin, whose music set the tone for a great opening; Christina Delguste, Interpretation, facilitated the Gallery Guide; Fatima Tigmi, Administration, made sure I had spent all my money on time; Greg Pilsworth, A/V, worked tirelessly on creating a wonderful video of all the artists; Allan Cottrell, Digital, supervised the technical aspects for each installation; and Harry Foster photographed the artists in the right spot on the right day.

Charlotte Townsend-Gault, Nancy Marie Mithlo, and Paul Chaat Smith made important contributions to the burgeoning field of critical writing in aboriginal contemporary art.

Others we met along the way include the artists Charlene Teters, Sarah Bates, and Eric Robertson; Jim Volkert, Peter Brill, and Terence Winch, of the Smithsonian's National Museum of the American Indian, New York, where *Reservation X* will make its second mark; editor Marcia Rodríguez; and finally, Julie Scriver and the partners and staff of Goose Lane Editions, who created a beautiful book.

But above all, it is the artists themselves who must be honoured. Mary Longman, Nora Naranjo-Morse, Marianne Nicolson, Shelley Niro, Jolene Rickard, Mateo Romero, and C. Maxx Stevens provided the spirit for this project. Each of them has given us new ways to look at aboriginal communities with inspiring and original art that promises to challenge our views of community and identity. We hope their works and ideas will continue to give back to their home communities what they gave us.

Megwitch!

Gerald McMaster
Editor and Curator, *Reservation X*

THE ESSAYS

LIVING ON RESERVATION X

GERALD MCMASTER

> I think this quest for space or for sense of place, reinventing the notion of place, is a peculiarly Euro-American artifact. It's an artifact of alienation, of movement about the earth, and Indian peoples, at least in their indigenous contexts, didn't have to worry about abstracting something called "place" from their very existence. They already were somewhere; they already belonged somewhere.
> — Alfonso Ortiz

What is this place that Canadians call the reserve,[1] Americans call the reservation, and some call "the rez"? For most contemporary aboriginal peoples the reserve is, was or will be home. It is a negotiated space set aside for Indian people by oppressive colonial governments to isolate them, to extricate them from their cultural habits, and to save them from the vices of the outside world. Paradoxically, isolation helped maintain aboriginal languages and many other traditional practices. The reserve continues to be an affirming presence despite being plagued by many historical uncertainties, even if, as many non-Indians believe, "reserves are for Indians." The irony in this statement has been the glue that gives aboriginal people their identity after more than one hundred years. In recent years, land claims ensure the reserve's survival and prosperity. Although it may be difficult to view these places as prisons, at one time Indian people needed special passes to leave the reserve boundaries. John PeeAce and George Peequaquat recall life on the Nut Lake Reserve in the 1940s: "We could not leave the reserve without a pass, we were prisoners, and we could barely survive. There were gates on the fence around the reserve. We had to beg and barter with the neighbouring off-reserve farmers, but before we could do even that we needed a pass to get there."[2] It is also hard to believe that this system inspired pre-Mandela South Africa to invoke similar enslavement for aboriginal Africans some fifty years ago. Imagine, however, that these same reserves will always be both a symbolic and real home for most Indian people.

Notwithstanding Ortiz's partial rejection of the idea of place, Indian people today, and this exhibition's artists in particular, have by circumstance created unimagined discursive spaces. The reality is that fifty percent of aboriginal people in Canada and the United States now live off-reserve. As will become evident, continuous movement from one place to another by Indian people makes individual identity problematic

because of a need to belong to some community. For Indian people, historically, urban living renders attachment urgent. They continue to greet each other by asking: Where are you from? It is no longer embarrassing to say that one is from a place that is not a reserve, although this may be prefaced by pointing out a parent's specific tribal territory. Even communities thought of as isolated have always had access to the outside world, and global communication now makes isolation impossible. It is within this complexity that we quest after a sense of place, of community and identity.

COMMUNITY AND IDENTITY

Reservation X concerns the ideas of community and identity. As many of the artists affirm, a contemporary community is no longer a fixed, unified, or stable place; it exists in a state of flux. Communities were often a means of maintaining some sense of order and coherence. They established sameness, thereby making difference difficult. Similarly, identity is seen as multiple and mobile against the stable and homogeneous concepts of the past. Language and religion, the great integrating forces, are now in crisis. As the world grows more complex, so do our communities and identities. We may say that we are from there, when really we are from here; tomorrow we will be from over there. Similarly, we can no longer define ourselves as this or that; we are now both and more.

The initial idea for *Reservation X* began as a way of investigating why some contemporary artists value the importance of belonging or connecting to an aboriginal community. This raised such questions as: What is the artist's role in, and how does the artist contribute to, a community's cultural identity? In turn, how is the community giving artists an identity? And what is the relation between an artist's community of choice and the mainstream art community?

In early 1996, research/studio visits were made to the selected artists' homes. It became evident that individual circumstances led each artist to conceptualize community in multiple ways. Some artists born and brought up in an aboriginal community continued to live there; others born and raised in urban areas have since moved to a reserve community. Still others, born and working in urban spaces, maintain links to both urban and rural communities. Their ideas of community and their quotidian experience reflected different perspectives; yet all were essentially aware of their affinity to aboriginal identity.

(IM)PERMEABLE SPACES

What is Reservation X? The inspiration came from Shelley Niro's film script for *Honey Moccasin*: "The locale . . . is a Reservation X otherwise known as the Grand Pine Indian Reservation." Her point about the plot taking place on Reservation X characterizes a reality of place for contemporary Indian people, a community that is at

once fictional and real, but nonetheless a place with a story. We are to be forewarned that a reservation narrative is at the threshold, and with the release of *Honey Moccasin*, our desire to know more about life on the reserve creates a permeability. In Canada, these narratives have become familiar in television dramas like *North of 60* and *The Rez*. Crossing the mysterious frontiers of the reserve, so long out of reach to outsiders, is now much easier. Niro and the other artists in this exhibition get us there through individual narratives.

In the first place, the mystery of *X* is a historical moment. In late-nineteenth-century treaty signings, Indian chiefs had their hands held in order to sign an *X* as a mark of their consent and understanding of the political process: *X* Poundmaker, his mark; *X* Red Pheasant, his mark, and so on. *X* signified articulation; it left a trace, even for those unable to speak. Despite the uniformity of their signatures, marking an *X* belied their intelligence. The *X* was contradictory; it indicated inarticulation. These *X*s created the reserves.

Where is Reservation X? Today, the idea of Reservation X does not limit our understanding of those territories called reserves. Of the large percentage of aboriginal peoples in North America who live in urban centres, a majority of that number would consider their birthplace urban. The urban and rural now make up two discursive spaces or communities that form the new reservation narrative.

The mystery of Indian territories is like the impermeability of a certain subject: although we see it, we don't understand it. The nature of the reserve is rapidly changing, however. Struggling to maintain its meaning for both the people who live there

and for urban Indians and whites who consider visiting it, the reserve has been both sanctuary and prison. Harold Cardinal observes, "In the language of the Cree Indians, the Indian reserves are known as *the land that we kept for ourselves* or *the land that we did not give to the government.*"[3] The reserve has kept Indians apart, allowing aboriginal people to live differently from outsiders. It is this difference that is now becoming attractive and permeable. Territoriality is fundamentally important to Indian people, and the Indian reserve is a territorial space that signifies "home," a place that enables and promotes a varied and ever-changing perspective. It is a frontier of difference and a place to which one can always return.

For some Indian people, this home is often the reserve. They may return to participate in Powwows, Potlatches, Corn Dances, or Kiva ceremonies, or to attend weddings or funerals and other rites of passage. For many, this does not mean a return to the margins; rather, it is a return to the centre of activity, which provides points of reference for those in search of a dialogue with identity and community. Thus, by inverting the stereotype of the reserve as somehow outside the core of the state, a new, enabling trend occurs.

From the artists' perspective, utopian communities are a thing of the past and can be signified only poetically. There was a time in the 1960s and 1970s when cultural identity was at its zenith and many young people longed for an alternative way of life reminiscent of some golden age. That era contributed to greater consciousness of community, of living with others, and of sharing ideas. What has survived from those days is a strong commitment to preserving fundamental philosophies and principles. Going back home, living on Reservation X, contributing to local culture, is now accessible for many.

THE REZ

Who lives on Reservation X? In an era of land-claims and self-determination, aboriginal communities are taking more responsibility for their internal affairs. Greater numbers of those receiving advanced degrees are also contributing to the betterment of their communities. Indian people once moved home when they reached a certain age to become part of the whole again. Moving back is now a more common event. A number of artists have recently returned home, only to discover some interesting results. This trend inspired *Reservation X*. Yet not everyone returns. Some prefer cities. Some have returned, only to re-depart, this time with a developed disposition. Jolene Rickard, after years of urban living, was asked by her family to return and contribute to the reservation community; Marianne Nicolson went back to the place where her mother grew up, feeling that she needed to make connections. Mateo Romero moved to his wife's reservation of Pojoaque; Shelley Niro lives at the edge of the Six Nations Reserve in the town of Brantford. Nora Naranjo-Morse continues to live on her reservation of Santa Clara, while Mary Longman and C. Maxx Stevens have chosen to live in cities for educational or professional reasons.

The laconic term "the rez," which has been around for some time, is gaining wider usage in the arts. The popular CBC television program *The Rez* features young aboriginal actors on some Reservation X. "The rez" is a cool expression taken up by young urban Indians to refer to a cool Indian community. Its hip-hop style abrogates our old understanding and infuses it with new, powerful, and ironic messages. Contemporary authors and artists find this usage resonating with a bold and tenacious spirit. It is a term of appropriation and articulation, of taking something and using it to advantage. Rez talk now plays a part in the language of Indian country as does that of the "hood" in Black communities or that of the barrio in urban Chicano communities. Though the rez may now mean any Indian community, urban or rural, it signifies the idea as much as the complexities, paradoxes, and contradictions of living on the rez.

DISCONNECTIONS AND RECONNECTIONS

In this section, I examine the relationship of artist to community by looking at a small number of projects undertaken by Indian artists at a time when cultural affirmation was burgeoning.

Historically, artists were always very much a part of the community fabric. During the postwar period, however, contemporary aboriginal artists positioned themselves apart from their respective communities, becoming more individualistic by leaving the reserves and conforming more with the mainstream. This disconnection was symptomatic of a modernist world in which its adherents had originally wanted to express themselves freely without the pressure of community standards. Modernism became a conscious, forward-looking movement that wanted little to do with tradition, and it was characterized by always thinking in terms of the future, a tomorrow that is forever on its way.[4] If this is a necessary step in the evolution of contemporary aboriginal artistic practice, it is currently undergoing radical changes. Artists are attempting to merge the legacy of individualism with the dynamic and affirming bond of community. They no longer see the appeal of being marginalized iconoclasts but prefer to become active participants, where community and individual growth are not incompatible but complementary goals. By understanding the logic and evolution of their practices, we may be able to see some critical connections and reconnections.

THE AMERICAN SOUTHWEST

The American Southwest has had the longest and most continuous artistic development of any place in North America. Artists gravitate towards the art market centres of Santa Fe, Albuquerque, and Phoenix, where many make a highly successful living. At the same time, artists of a traditionalist spirit have gone on producing works that are more at home in the community as functional pieces and works of art. Pottery, jewellery, woven blankets, katchina dolls, and basketry — all continue to reach diverse

audiences. The Southwest has, however, long set standards for creating an art that is responsive to community needs and identity.

It is not surprising that the contemporary Southwest phenomenon began in New Mexico during the first half of the twentieth century at the Santa Fe Indian School, which in 1962 became the Institute of American Indian Arts (IAIA). Influential in virtually every corner of the art world where Indian artists are concerned, it has recently been found clinging to life. Like Black Mountain College in western North Carolina, IAIA has always had a strong identity and sense of community, which is why it attracted young Native Americans from reserves, reservations, and urban areas all over the continent who wanted to train as artists with other Native Americans. The art taught and created was both contemporary and traditional, and the school's creative synergy pushed students to produce leading-edge work. Unlike Black Mountain, which was known more for its teachers, IAIA was a place for students. They gave IAIA its identity and sense of community. While it continues admitting students, the intensity that once was its driving force has lessened. Some artists have no need of school, while others seek different forms of art education. Nevertheless, IAIA gave young aboriginal students a sense of purpose in the days when Native American educational institutions were few.

THE CANADIAN WEST COAST

A similar though tenuous artistic production on Canada's West Coast comes closest to the Southwest style. One family of Kwak<u>aka</u>'wakw sculptors has now become legendary, beginning with Willie Seaweed (c. 1873-1967), Mungo Martin (c. 1881-1962), Henry Hunt (1923-1985), Tony Hunt, Sr., (b. 1942), and continuing today with Calvin, Richard, and Tony Hunt, Jr. The Hunts produce works for an international market, often travelling around the world to install a new pole or raising one in their local

ALFRED JOSEPH, A CARRIER INDIAN, WORKING AT THE
KITANMAX SCHOOL OF NORTHWEST COAST INDIAN
ART, GITKSAN ('KSAN), BRITISH COLUMBIA, ON A
CARVED AND PAINTED MURAL WHICH IS NOW IN THE
ROYAL BANK BUILDING, VANCOUVER. A NUMBER OF
PAINTED CEDAR SCREENS LIKE THIS ONE FOUND NEW
HOMES IN PUBLIC BUILDINGS DURING THE 1970S.
COURTESY OF DR. GEORGE MACDONALD

community of Prince Rupert. They represent a rare, unbroken line of sculptors who are still involved in traditional community events.

In the late 1960s, the northern British Columbia community of Gitksan ('Ksan) set up a school to provide economic opportunities for young artists to revive interest in Northwest Coast Indian art. Opened in 1970, it became known as the Kitanmax School of Northwest Coast Indian Art. Several artists from outside the community came to teach, often influencing their students to create works that were based not on the local tradition but on an amalgam of styles. As Peter Macnair comments, "Unfortunately, none of the teachers had full command of Tsimshian artforms, especially the sculpture, and, as a result, three-dimensional objects produced at 'Ksan lack the tranquil refinement of older pieces."[5] In 1971, Walter Harris, one of the school's local artists, carved a pole and raised it in his community of Kispiox, an act that greatly enhanced 'Ksan's profile. Although the Kitanmax building continues to stand, its programs and influence have long since dissolved. Yet in its prime it created a strong sense of identity and community in all its artists, and for that reason it is important. Unlike the aboriginally inspired universality of IAIA, 'Ksan's focus was regional. Many of the Kitanmax artists soon realized the strong attraction of their own community identity and moved back to their particular communities to express it. The regional and pan-Northwest Coast appeal of Kitanmax soon lost its significance. Today, many West Coast artists work in the large art centres or in their local communities.

INDART

In the early 1970s, I was fortunate to work for nine months with the late Sarain Stump (1945-1974) at the Saskatchewan Indian Cultural College in Saskatoon. We travelled to the many reserve schools teaching Indian art to children from grades one to twelve. In the late summer of 1973, I left to attend IAIA in Santa Fe. Although Stump continued, we realized the need to train young Indian artists to carry on the work. Later that fall, Stump began a program with the quirky title Indart. Several students enrolled, including the now-distinguished Edward Poitras. The following summer, students set up a camp on the Moose Woods Reserve south of Saskatoon,

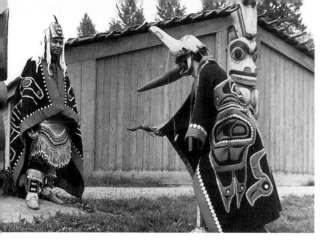

where they lived as a small community. Stump soon began inviting other Indian artists from across Canada as instructors, including Walter Harris and Wilma Simon. Stump's untimely death in December, 1974, shocked the community. So intense was his personality that the program almost died with him. In the late 1970s, the school, located at the Saskatchewan Indian Federated College, University of Regina, went on to become the only accredited Indian art program in the country. Like 'Ksan, Indart infused all its staff and students with a strong sense of identity and community. The program continues.

MANITOULIN ISLAND

In the 1970s, Manitoulin Island was another centre that inspired and placed many local artists at the forefront of a mythological discourse. The two communities of West Bay and Wikwemikong produced several young artists and, through the Manitou Arts Foundation, sponsored summer art programs. Elders were frequently brought in to inspire and instill wisdom and knowledge. These programs offered art as a means of expressing identity, particularly through art forms based on mythological themes. Many of the artists such as Blake Debassige, James Simon, Leland Bell, and Don Ense remain in these communities, now largely invisible to the outside art world. They continue making art for themselves.

An artist from Manitoulin Island who did not participate in the programs is Carl Beam. He left in the 1970s for work and art school, and for a short time in the early 1980s he lived in Española, New Mexico. Eventually returning to Ontario, he brought back a sensibility and respect for the Southwest. He did not, however, import the stylistic influence of the Southwest. Instead, he brought back something more powerful, a sense and understanding of the land. Beam has been described as a *bricoleur* — a handyman/ artist able to transform found material into new work. The material in this instance was the earth, more particularly clay. He discovered that its corporeal properties inspired him to extend an already overdetermined sensibility. At first, he used clay to make pots that had his familiar, difficult-to-read collages on the inside and outside. He continued his work in clay until he realized that its materiality could be extended beyond the realm of artmaking. Rather than abandoning artmaking, he began to see a social side of this material, an earthy concept of taking it outside the gallery into the community. He had already begun to show aspects of these ideas in commercial

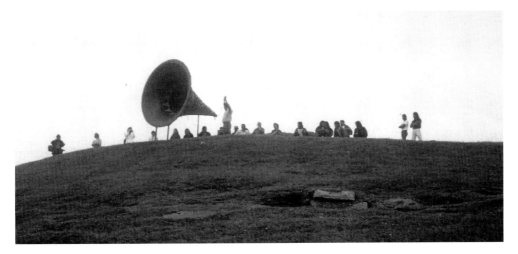

galleries, but the thought of taking it to the community eventually led him to move back to Manitoulin Island, where his goal was to make affordable housing for the people. Beam's new sociality is community inspired, socially responsive, and aesthetically pleasing. Although he has proved that he can live inside an adobe house in Ontario, he has yet to convince others. His arguments — that adobe is an affordable alternative to expensive and rapidly diminishing wood products and warmer and tighter than wood — are somehow failing to strike a community chord. Perhaps people feel that there is an unending supply of wood, that the house is not structurally sound, or maybe it simply looks too unusual. Beam continues to improve his design, undaunted by community reaction. Someday, someone will knock on his door and begin asking questions about the earth. He will probably say something similar to what Nora Naranjo-Morse said after she built her adobe brick house: she now has a completely new respect for it as a material. It is earth, yet its properties, like gold, are innumerable. Only by working with it can we begin to understand it as a life-giving force.

REBECCA BELMORE

Initially presented in Banff, Alberta, in 1991, Rebecca Belmore's sound and performance installation, *Speaking to Their Mother*, is not a community project. Like the work of Carl Beam and other artists, however, including those in *Reservation X*, Belmore's work prompts us to consider new ways of determining the variable meanings of community.

Belmore arranged a cross-Canada tour, asking aboriginal people from across the country to participate. There are at least two ideas inscribed in this piece: commu-

nication and sacred time/space. In the performance, several people speak into the attached microphone, their voices amplified by the megaphone. The work brings to our attention the continued belief in the relation of humanity to the rest of nature. Belmore created an opportunity for everyone to speak to the universe without prejudice, fear, or embarrassment, because at the moment of enunciation, everything and everybody — the animals, the grass, the wind, the rocks, the sun, the mountains — witness the address. Belmore's work in this instance depends on performance and space. Her use of technology as a medium of communication is not an issue; similar technologies are continually used in large public gatherings by aboriginal people. Amplification is for reaching beyond. We raise, lower, or mediate our voice, depending on the space or situation. Belmore's point is not just amplification, but a belief in the power of communion with an audience.

The second idea relates to the space where the expiation occurs. Her insistence that the event take place outdoors carries with it the idea of inclusiveness — everybody and everything participates. Everyone is equal, no one greater or lesser than the next. What she helps create is a sacred time, a liturgical moment, where every responsible action is subject to everybody and everything. As traditional spiritual beliefs indicate, there are key times of the year for large formal performance gatherings but none for personal enunciations. Belmore's performance is more informal and not subject to specific tribal orientation; rather, she creates time/space and context.

NEW REFERENCE POINTS

Why is Reservation X important and for whom? I suggest that between two or more communities — reserve and urban — there exists a socially ambiguous zone, a site of articulation for the aboriginal contemporary artist that is frequently crossed, experienced, interrogated, and negotiated. This idea argues for a space of radical openness and "hybridity," or spaces of resistance being opened at the margins. I, however, see this space as in between two centres, which is a politically charged, though highly permeable, site.

Aboriginal contemporary artists, like other artists, often reflect the conditions of their times. These artists move freely between different communities and places, often within a new "third space"[6] that encompasses the two. They are able to see, borrow from, and articulate within the two spaces. They understand the aboriginal community and the mainstream; at times they question the two, sometimes they subvert them. They see boundaries as permeable and culture as a changing tradition. Aware of family and community dynamics as constituting identity through language, sociality, and the unconscious, aboriginal contemporary artists have accessed new and different reference points, of which the reserve is a major catalyst.

Some communities view artists as important for expressing visual identity. Always skilled articulators of culture and community identity, for many years aboriginal

contemporary artists were led into the discursive boundaries of the mainstream, since it gave them an identity as artists and potentially important artists. Yet in striving to legitimate this identity, they brought with them baggage that was often dismissed by the gatekeepers as not quite art — a logic akin to the cowboy/Indian dichotomy, where the equation is not quite balanced. On the one hand, "cowboy," like "artist," is an occupation anyone can choose. Being Indian, however, is a far more complex formation of identity and community. Anyone can become an artist, but not anyone can become an Indian. The identity of the artist is mobile and unfixed, as is the artist's cultural identity, yet together the two identities contribute to the makeup of a complex subject of the modern age.

What are the ways in which this idea is being articulated? Contemporary artists place greater value on self-determination, a willingness to be an individual yet unconsciously tied to place. "Returning home" means contributing and reconnecting to local culture. Living and working in a changing world while maintaining a sense of identity is to recognize the importance of preserving fundamental philosophies and principles. The community projects of 'Ksan and the IAIA of the late 1960s provided many artists with a new sense of identity and community. In the following decades, however, contemporary artists of aboriginal ancestry struggled to become recognized players in the mainstream. In the process, many succeeded in becoming nationally and internationally distinguished. The late Haida artist Bill Reid is one example.

Meanwhile, the mainstream itself has undergone major ideological shifts, fuelled in part by artists outside the dominant Western canon and in part by the growing recognition of pluralism and difference as leading indicators of change. These changes include notions of cultural identity, an artist's relation to community, and the questioning of individualism. This is the so-called postmodern moment when boundaries are blurred and more permeable, when communication and economies are becoming globalized, leading to a kind of creative confusion. Furthermore, we are witnessing artists physically and psychologically moving about. Greater numbers of aboriginal artists are pursuing an education in fine arts or art history, being exposed to new ideas, and asking new questions. They question the mainstream and their role within it. Indian artists also question their identity as Indian — can they continue to be "Indian"? — and its value in a changing world.

Crossing intellectual frontiers to meet people and exchange ideas reflects the cogency of artists coming together to share in this experience. It is about any space or any place where these artists have lived, where they now live, or where they will live: it is about being elsewhere. It is about the permeable spaces of rural and urban aboriginal communities, where artists move in and out. As Jolene Rickard confirms:

> We are not interested in somebody who wants to mutate and hybridize the seeds. We want to keep the seeds going because they will feed our people for the next seven generations. It literally feeds us. At the same time it is that thing that we can centre ourselves around to feed us on the spiritual and cultural level.

Notes

1 Today, "Indian Reserve" is problematic; many tribal governments prefer the phrase "First Nations" to indicate their unique historical status in relation to Canada's so-called founding nations.

2 In Jack Funk and Gordon Lobe, . . . *And They Told Us Their Stories: A Book of Indian Stories* (Saskatoon: Saskatoon District Tribal Council, 1991), 32.

3 Harold Cardinal, *The Unjust Society: The Tragedy of Canada's Indians* (Edmonton: Hurtig, 1969), 29.

4 Marco Senaldi, "Michel Maffesoli: Sociologist, the Sorbonne," *Flash Art*, no. 177 (summer 1994), 59.

5 Peter L. Macnair et al., *The Legacy: Continuing Traditions of Canadian Northwest Coast Indian Art* (Victoria: British Columbia Provincial Museum, 1980), 93.

6 For further development of this idea, see Gerald McMaster, "Border Zones: The 'Injun-uity' of Aesthetic Tricks," in *Cultural Studies* (London: Routledge, 1995), 74-90. For more on the "third space," see Edward W. Soja, *Thirdspace: Journeys to Los Angeles and Other Real-and-Imagined Places* (Cambridge: Blackwell, 1996).

THE MEANING OF LIFE

PAUL CHAAT SMITH

They were anxious and bored, for all the right reasons. Nothing was happening anywhere, and most days it seemed likely that nothing ever would. Indian kids of North America — angst-ridden, their moods swinging in a heartbeat from dreamy to despairing — waited with dramatic impatience, wondering if time had actually stopped, or if it just seemed that way. They weren't even sure exactly what they were waiting for, or how they would recognize it if it ever showed up.

On that score, at least, they had nothing to worry about. You could see the issue of *Life* from two blocks away, with or without sunglasses. The most influential magazine in America was known for its bold covers. But no previous cover had ever looked like this.

Letter-carriers in a thousand small towns must have been tempted to bury the thing under John Deere catalogues and weekly newspapers, or at least fold it so only the cigarette ad on the back would be visible. That way, at least, pedestrians, and especially children, might be spared the shrieking psychedelic atrocity that, inexplicably, occupied the cover. The new issue of their trusted friend, *Life* magazine *(Life magazine!)*, looked like a recruiting poster for hippie subversion.

The graphic design legend Milton Glaser was the culprit. Executed in the style of pop artist Peter Max, Glaser's screaming oranges, violets, yellows, and pinks made the magazine's famous red and white logo all but disappear.

A small black-and-white photo of one of those Indians from the last century was at the centre, wearing an army coat and staring hard straight into the camera. He was engulfed by a crazy Day-Glo illustration of, presumably, an Indian from this century. The Indian had a Mohawk and looked left; open the gatefold and you saw his twin looking right. The cover headline offered this explanation: "Return of the Red Man."

The articles were an uneven lot and spent more time on hippies than Indians, but once you got past Julie Christie modelling "hippie Indian leather breechcloth and beads," there it was: a spread on the Institute of American Indian Arts (IAIA) in Santa Fe. The article offered powerful evidence that something, in fact, was happening somewhere, and it answered the prayers of lost teens from Medicine Hat to Miami. *Life* had given them life.

At this school that was like no other, "you can even hear the cultures colliding." Diana Ross and the Supremes coexisted with war chants and drumming. There were

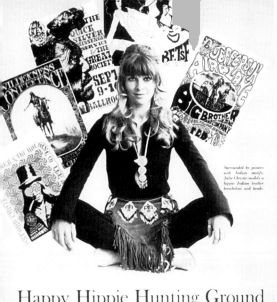

Happy Hippie Hunting Ground

The hippies' infatuation with the old ways of braves and squaws has not gone unappreciated by real Indians. "Hippies," says Rolling Thunder, the militant chief of the Shoshones, "are the reincarnation of the traditional Indians who have fallen. They are the ghosts of warriors who have come back to reclaim their lands."

In their reclaimed hunting grounds, hippies try earnestly to achieve authenticity. In Millbrook, N.Y., they live in tepees, in Santa Fe in hogans, and in Big Sur in tents. Some travel to the Southwest to learn directly from the Pueblos and Hopis how to live off the land, how to find wild vegetables and herbs, how to raise corn and rabbits, how to weave baskets, even how to stalk game and tan hides. They seek out the old men who still remember the tribal patterns, for hippies are enormously attracted to the Indians' communal society, where all is shared and there is no feeling for property or material possessions, where disputes are settled through talk, where there is a sense of group ceremony and ritual.

In the cities, hippies have organized themselves into tribes. Some are small, five or 10 people who sample living together in a pad or house, sharing possessions, food and taking drugs together. But other tribes are more elabo-

CONTINUED

Indian kids talking about their identity, about the modern art they were making, about the new trails they were blazing, even as they kept faith with the old trails, participating in Hopi and Navajo ceremonials. They had a kind of cool self-confidence that was for the time revelatory, even shocking. "In the painting classes, students who have been scarcely exposed to the Western tradition of realistic representation turn out to be naturally gifted abstractionists." (The article attributed this to "hereditary talents" from so many centuries of geometric art.)

Turn the page and there's a colour photo of an Indian rock-and-roll band, four guys and a girl singer, apparently just returned from a successful shopping trip to London's Carnaby Street. English hair, English clothes. Ties, turtlenecks. The singer's dress is black and white striped, and she's wearing white shoes and white tights. They are perfect. A guitarist wearing shades is captured in mid-leap, and the drum kit announces the name of the band: The Jaggers.

Never had the tired, shop-worn platitude supposed to guide the lives of Indian people — the one about walking and living in two worlds — looked so vibrant, so exciting, so sexy, so alive. We could have Rothko and beadwork, Motown and the British Invasion and the tradition of our Crow and Navajo and Apache ways. We could have it all, and here in *Life* magazine was irrefutable proof.

If it had all been some kind of cruel hoax and there were no articles inside at all, just the *Yellow Submarine* cover and the promise of returning red men, it still would have been pretty thrilling for Indian kids who lived in small towns with no apparent future, towns where the sixties were little more than a vague rumour. (The subversion of all those self-conscious mailmen was a cause for celebration all by itself.) But for the ones who had been waiting, the 1 December 1967 issue of *Life* magazine was nothing less than a postcard from the future.

It changed everything for Richard Whitman, a young Indian living in Oklahoma. By the time he finished leafing through the glowing pages, he was already planning to make that future his own.

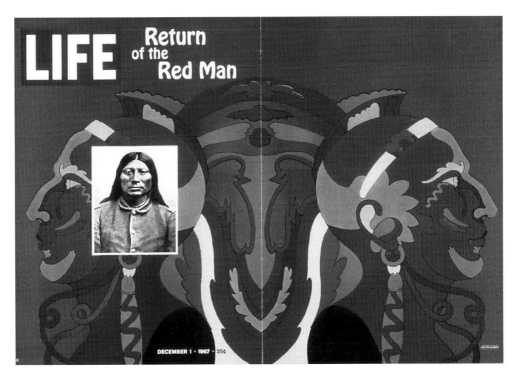

LIFE, 1 DECEMBER 1967. THE NOTORIOUS COVER, FROM THE FIRST DAY OF THE LAST MONTH OF 1967 — ARGUABLY A DATE THAT MARKED THE FEROCIOUS HIGH TIDE OF THE COUNTERCULTURE, CIVIL RIGHTS, AND ANTIWAR REBELLIONS THEN ROCKING NORTH AMERICA. THE ARTICLES AND PHOTOGRAPHS CAPTURE AN INDIAN WORLD NOT YET DEFINED BY THE LANGUAGE OF PROTEST AND SELF-ROMANTICISM THAT WOULD BECOME ALL TOO FAMILIAR A FEW YEARS LATER. GRAPHIC COURTESY OF MILTON GLASER, *LIFE MAGAZINE* © *TIME* INC.

The stories and pictures electrified Indian kids in Oklahoma and Montana and Los Angeles because Indians in 1967 were invisible and boring. Guys who, decades later, would be renowned as movie actors or revolutionaries often claimed to be Italian or Greek, not to avoid rednecks but because it was more stylish. Anything was.

The famous joke from those days, the one that proved Indians had a wonderful sense of humour, nailed the era exactly. An Indian, because of some BIA (Bureau of Indian Affairs) error, is assigned an excellent piece of land by the river. He makes the most of this, working hard sunrise to sunset, and his diligence and the rich land make his farm a success. He falls in love and marries the woman of his dreams. After a few years he's doing so well that he decides to take on a farmhand. The farmhand is white. One evening he's drinking cheap whiskey by the river, wondering why he is working for the Indian when it should be the other way around. He drinks some more and becomes more and more angry at the injustice, until he sneaks up to the main house and sets it on fire. The Indian returns from town to find his wife dead in the smoking ruins of his house. The white man is nowhere to be found. The Indian is devastated and vows that he will find the white man who did this, no matter how long it takes. Ten

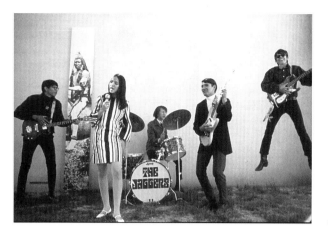

years later, the Indian finally tracks down the farmhand at a gas station in Timbuktu. The Indian confronts him and says, "Ain't you the one that burned down my house and killed my wife?" The white man looks back and says, "Yeah." And the Indian says, after a long pause, "Well, you better watch that shit."

The tragic hero of the age was Ira Hayes, the Pima Indian who helped raise the flag at Iwo Jima in World War II. His celebrity burned so bright that Hollywood made a movie of his life starring Tony Curtis. But Ira Hayes returned to his Arizona reservation to find nothing there for him but drink and pain, and he died at thirty-two in a drainage ditch. A maudlin song by Johnny Cash provided the soundtrack: "Call him drunken Ira Hayes, he can't hear you anymore . . . "

We were, in those days, losers. We were England before the Beatles, Russia before Gorbachev. Indians were history, an elementary school homework assignment, tedious pictures from a family vacation.

But then *Life* magazine arrived and said it could be different, that it already was different, at least in Santa Fe, where Indians were beautiful and mod and happening and traditional all at once. This was real. It wasn't a joke. No wonder Richard Whitman decided it would be his next destination.

Thirty years later, the colour photos and breathless text are, if anything, even more compelling. They are visions of a parallel universe of sorts, a recruiting brochure for what might have been, provoking the same kind of wonder as trinkets and home movies from the 1964 World's Fair: how could we have ever been so naïve, so young, so optimistic, so wrong? They each predicted a future that never arrived.

The pavilions in Queens imagined technology as the solution to every need, with safe atomic power and flying cars and homes under the ocean and in outer space. The new and better Indian future would arrive through the miracle engine of education. It was no accident that IAIA was a showcase for this alternative future. IAIA was, in fact, the crown jewel of the BIA's much-maligned school system. Foreign dignitaries often visited, and once students even performed at the White House.

Critics might argue that IAIA had about as much in common with most Bureau schools as Harvard did with the average high school, but training elites was hardly a

discredited strategy in the 1960s. They were our best and brightest, and who else should be at our best institution?

At the same time that Indian kids in Santa Fe were mastering rock and roll and Abstract Expressionism, others, only a bit older, were challenging established Indian organizations in the United States with a brash, confrontational attitude, freely borrowing language and lessons from third world anti-colonial movements. The National Indian Youth Council (NIYC) was the political equivalent of the campus in Santa Fe: the cutting edge of Indian radicalism in 1967. They were smart, ambitious college students, mainly from the southwest, often from better families, who were proud to call themselves intellectuals and who ran their meetings using parliamentary procedure. They also had an uncommon flair for self-promotion, describing themselves, for example, as "Red Muslims" or giving NIYC leader Mel Thom the nickname "Mao Tse Thom." They stayed current with the latest French philosophers, and they spoke easily of Vietnam and the War on Poverty, automation and the emptiness of modern life. It was true they had perhaps more press clips than troops, but that was starting to change. They fought the state of Washington over fishing rights, bringing Marlon Brando along for the ride and with him some national press.

Dig the new breed: dazzling creative ferment in the southwest and a cadre of indigenous radicals already setting their sights on the Indian establishment. Few doubted they would be key figures in the political and cultural change everyone knew was coming.

The future arrived even sooner than expected, and the changes it brought were more startling and wide-ranging than most imagined. And the hip kids of Santa Fe, along with their cousins in the NIYC, had almost nothing to do with it.

November, 1969, two years post-*Life*: boatloads of Indian college students staged a daring night-time invasion of the abandoned federal prison on Alcatraz Island in California. They claimed possession through a clever and witty proclamation, and the event became a media sensation in the San Francisco Bay area, winning headlines across the country. The students bravely defeated a naval blockade, managed the intense press attention, and, suddenly, realized that the media and even the federal government were taking them more seriously than they ever could have dreamed. They tried to organize themselves so that an occupation most thought would last a day or two might survive weeks or even months.

They named themselves "Indians of All Tribes" because that is what they were. For a brief time it was inspiring and wonderful, and then everything blew up.

A month after the landing, a coup had replaced the popular and charismatic leader of the occupation, a child had fallen to her death under mysterious circumstances, and the shower of positive news stories had been replaced by dark accounts of teenage thugs, drinking, violence, and mindless destruction.

The college kids who led the occupation had returned to their campuses. They were replaced by Indians from the Bay Area who for the most part led much harder, and very different, lives. The occupation would remain troubled throughout its nineteen months, and it never came close to achieving the dubious and impossible goal of creating essentially a "reservation" on the island.

Yet Alcatraz, despite its many failures, changed the rules of Indian activism. It had captured more press attention than all the Indian struggles of the entire century. It showed that Indians from all walks of life were far angrier than anyone thought and more willing to use militant forms of protest previously thought to be "un-Indian." And the event's profoundly democratic essence would establish the style, attitude, and nature of the Indian movement to follow. Alcatraz was open to every Indian, from middle-class business owners to the drunks from the Mission District, urban and reservation, young and old. It was exhilarating and sometimes dangerous. The newly liberated territory's "every Indian" rule didn't include exceptions that banned rapists, bootleggers, opportunists, and psychotics. Governance was virtually impossible. And it was crazy to think the decaying maximum security prison could ever have been a university or social centre. But even with all of that, more Indians responded to Alcatraz than to anything the more responsible elements of the Indian world offered. They responded because they felt invited, and no Indian organization had ever invited them to one of their conferences. They responded because the joke about the Indian and the white farmhand was no longer funny. They responded because, just maybe, at Alcatraz they would find answers to questions they were only beginning to realize they had.

After Alcatraz came a season of rebellions and occupations that touched nearly every part of Indian Country. Some actions were well-organized, most were not. Street-fighting, bravado, and apocalyptic rhetoric became the signature of the movement's leaders, none of whom described themselves as intellectuals. The American Indian Movement (AIM), which had become the leading organization in the United States, often spearheaded campaigns and provided support to local activists, but many times Indians would stage a demonstration or takeover without any outside connections. With few exceptions, the activism was, like Alcatraz, democratic, perhaps to a fault; usually it was made up of people from many different tribes and from both cities and reservations. Unlike other social movements of the time, it embraced people of all ages, from the very young to the very old. College students were there, too, but usually as followers.

In March of 1973, the movement included Richard Whitman. He had made good on his promise to attend IAIA, and later he moved to Los Angeles to pursue further art studies. It was there that he listened to a speaker who had just arrived from South Dakota to explain the incredible pictures Richard and others had seen on the television news. AIM and Oglala Sioux activists had taken over the village of Wounded Knee, and the government had surrounded them with hundreds of federal agents armed with Vietnam-era weaponry. The speaker pleaded for reinforcements, and Richard Whitman, two days later, found himself a very long way from art classes in Los Angeles. He was now one of the distant, wavering images on the evening news, armed with a hunting rifle, looking out across the frozen prairie at a thousand heavily armed federal marshals.

It is our people at our looniest, bravest, most singular and wonderful best, and moving beyond words even to those of us who resist cheap sentiment and heroic constructions of complicated and flawed movements. Yet there it is, over and over again: Indians who objectively have little or nothing in common choosing to join people they often don't even know who are engaged in projects as bizarre as laying claim to a dead prison on an island that is mostly rock, or picking up a gun to take sides in the Byzantine political struggles of the famously argumentative Sioux.

If Richard Whitman had been black and living in Chicago as the civil rights movement organized its campaign for voting rights in the American South, things would have been a lot different. A pair of unsmiling organizers in suits would have interviewed him at length, checked his references, and asked him probing, difficult questions, trying to determine whether he was tough enough to get knocked upside the head by some cracker and not fight back. They would look carefully at his academic record, church attendance, personal habits. He probably would not have been chosen. (If black Americans had had their own NASA, it could have been only slightly more difficult to become an astronaut.) And if he did succeed, the movement would provide formal, mandatory training before he would ever be allowed anywhere near Mississippi.

Certainly this is one reason the civil rights movement managed, in less than a decade, to destroy a system of legal segregation many thought would last for generations and win voting rights for black Americans.

The Indian method is less formal, less bureaucratic. Still, the very weakness of the Indian way of doing things turns out to be a profound strength, although one not without a high cost.

Alcatraz merits designation as the first Reservation X of the contemporary era. It was Indian initiated and directed, it was pan-Indian and intertribal, it was democratic and unexpected. For the outside world, it was understood as protest, a demand for recognition, a stand for respect and justice and acknowledgment. But it was also a place where Indians came for answers, to learn from people of different backgrounds, from different regions of North America, of different spiritual beliefs.

Significantly, people journeyed from vast distances to look for these answers. What compelled people from even the most intact of our nations, Navajos or Iroquois or Sioux, to go to San Francisco in 1969?

What did people mean when they stood in the cold wind on the broken concrete of Alcatraz and say they had never felt so free? And what did it say about the Indian political leadership, nationally and on a community level? About the Christian and traditional religious leaders of those communities?

I believe the spirit that moved so many Indians during that time comes from the recognition that rebuilding our shattered communities requires extraordinary intervention, daring, and risk. There was a clear-eyed, if often unspoken, acknowledgment that often our elders are lost or drunk, our traditions nearly forgotten or confused, our community leaders co-opted or narrow. They knew only one thing for sure: business as usual wasn't working, their communities were in pain and crisis, and they had to do something.

It was pretty much all over three and half years after Alcatraz, when exhausted, hungry rebels signed an agreement that ended the Wounded Knee occupation. There were other actions and protests, but none came close to capturing the imagination of the Indian world or challenging American power.

Although the movement won few specific victories — there was no fundamental change in Indian-US relations, no other success that matched what the civil rights movement won — communities were nonetheless changed. Young Indians today are surrounded by messages, from the mass media to band councils to government officials, that at least claim to support Native culture and values.

The defining moment for this Indian generation, the one Madison Avenue calls X, was everything the inspired craziness of the sixties and seventies was not: planned far in advance, well-funded by governments and foundations. It was about dialogue, not barricades; education, not sedition. It was the activity surrounding the Columbus quincentenary in 1992, and its spectacular failure has much to teach us.

The year 1992 was the logical extension of the post-revolutionary sensibilities, where pretty much any Indian this side of Wayne Newton could talk about Elders and Mother Earth and the Pipe at the drop of the hat. (It was as if we had collectively decided to forget it was post-failed-revolution.) And as we started talking more in generic terms about fuzzy concepts that sounded good and felt good, the non-Indian audience caught on and then moved on.

During the run-up to the big five-double-zero, a cartoon appeared in the *New Yorker* that we should have understood as prophecy. Two aboriginals are carving inside an igloo. One says to the other, "Sure it is. Everything we make is art." Obviously certain people were on to us.

Others liked *Dances with Wolves*, which swept the Oscars and which, at the time, seemed to be the perfect stage setting for the main event. Instead, it stole what little thunder was left in the humourless, Eastern Block-style public service campaign that we, along with our friends from the New Age and environmental movements, had carefully designed. The quincentenary was essentially an effort towards the political re-education of white people, who, as it turned out, couldn't have cared less about Columbus. And anyway they had already seen the movie.

The X had been answered. The answers were wrong, but they were easy to understand. "Oh," everyone said, "so that's it."

The curtain rose on opening night, and as we prepared to address the human race, we found ourselves looking out at a few hundred million empty seats.

It was, as failures are often reputed to be but rarely are, the best thing that could have happened. We should be thanking our grandmothers even now, and here's why. The world tuned us out for some bad reasons (racism, guilt, obsession with celebrity), but also for some solid reasons. We had become boring and preachy, an earnest docu-

mentary speaking to the converted. Somehow we had forgotten our native tongues and instead were using a patronizing dialect good only for clearing rooms.

The whole world wasn't watching. And this meant that instead of addressing the entire planet, we'd have to settle for talking to each other. And the conversation immediately became smarter and way more interesting.

The conversation is about love and loss, ceremony and drinking and histories and futures, legends and gaming, and how none of us has a clear idea of what to do next.

For most of the last thirty years, almost any Indian who painted or wrote, attended a university, played the violin, or flew a plane, in at least a small way made history. It was a political act simply to be human in the contemporary world. There was genuine doubt about whether we were going to be around or not, and if we were, whether we could cut it or not.

Those doubts have vanished. The work of affirming a continued Indian existence, of convincing ourselves and others that our culture is alive and dynamic, that history has often lied about us, that we are not all the same: this work is done. It will never be completed, and I fully expect that, in the year 2027, Indians will be answering questions about what Indians eat. But those items can now be safely crossed off our list. Indian people are clear about this: they want to remain Indian.

The debate today becomes harder, more painful, but just as important. The question is no longer whether we will survive but how we will live. It isn't about battling dead icons like John Wayne but rising to the challenge of creating our own visual history.

We are the ones who must make sense of Indian kids in Mexican villages who grieve at the death of a rap artist, or the implications of a new upper class being created by gaming and trade in some communities. We are the ones who have to consider when tradition becomes another style or when spiritualism becomes fashion.

Three decades ago Richard Whitman journeyed to Santa Fe to realize the intoxicating vision promised in the glossy pages of a weekly magazine. He found instead a cold, soulless place where commerce meant the same thing as art, culture was often a pose, and cynicism came as naturally as breathing. Whitman survived Santa Fe, and a few years later he even survived carrying a rifle on the front lines at Wounded Knee. These days he exhibits his photographs and video work in New York and Paris. Sometimes he'll make droll asides about the way *Life* changed his life, which it did, in fact, for the better. In the years after Wounded Knee and before 1992, the Cherokee artist Jimmie Durham wrote, "I feel certain that I could address the entire world, if only I had a place to stand." It is probably his most widely quoted remark. He believed that no relationship in the Americas is more profound or more central than that between Indians and settlers, and that nothing is more lied about. Indian artists who refuse to accept the lie, and who refuse to collaborate with the twisted colonial refuse of guilt and romanticism, he promised, would find it rough going.

He was certainly right about that.

I don't think we can lay claim to having built such a place — not yet, anyway. Perhaps, though, we've built something else: a space carved from hard lessons and bitter disappointment, a ruthless ambition for intellectual integrity and rejection of tired rhetoric, a passionate belief that our endlessly surprising communities are capable of anything, and a willingness to laugh, especially at the latest regulations from the Indian thought police. It's a whispered exchange in the cheap seats of the Toronto Skydome, a Cree manifesto inspired by Alan Ginsburg and Cochise posted on the Internet, and the work of the artists in these pages.

The space may not be grand, but it's ours, free and clear. Every other Thursday, you'll find it in the back room of a bordertown bar, the one on Highway 17, dead east of Reservation X.

Bring lots of quarters. The jukebox is legendary.

LET X = AUDIENCE

CHARLOTTE TOWNSEND-GAULT

Aboriginal contemporary art is no single or simple thing — it might be a basket or an installation, it could be a logo or a dance or a cartoon. The very idea of an aboriginal art is contested. It is fused by some histories and divided by others. Like the territories of its makers, it is bisected by international boundaries. Guided and trapped by its own traditions, it has been both blessed and cursed by ethnological attention. Sometimes acclaimed in the received history of twentieth-century Western art, at other times shunned, it has been both caught up in the fashions of post-colonial debates and ignored by them. The discourse of the avant-garde, of serious *high* art, at times intersects with it, at times does not. All the time all of this — what the art is and who it is for — is worked out in a continuous dialogue with its audiences.

The roots of this interesting situation lie in a history of differential power relations, in economic, ideological, and aesthetic conflicts, but also in conjunctures. Many complex exchanges have taken place, within aboriginal communities and between them and others, resulting in the nations that the Haida/Tsimshian scholar Marcia Crosby has identified as living in hybrid "urban landscapes," and what the Australian scholar Nicholas Thomas calls "socially entangled objects." *Reservation X* presents some of these entanglements — of ideas, influences and ways of looking — as they impinge on the lives of the artists, on the discourses of contemporary art, and on their audiences.

When Shelley Niro took up the term "Reservation X," she had in mind an extended community that was unknown only because it had resisted identification. That was its strength and its subversiveness. In Niro's usage, First Nations people are connected by what they share historically, cognitively, spiritually, even if — especially if — it is hard to agree on what that is. A free state out of reach of the usual codifications, Reservation X cannot be identified by numbers, by ID cards, nor by a place on a map, but by something less measurable and more meaningful. For Niro, "Reservation X is the source of our energy."

The idea of Reservation X contributes to the dislocating and relocating of the artist's voice. As this virtual place, this source of energy, is brought into focus, another X factor emerges — the destabilized, dislocated audience. This audience can be placed into sociological categories as, for example, Geary Hobson has done:

> In terms of politics and sociology it appears there are several ways of defining Indians: 1) the Indian tribe's or community's judgment, 2) the neighbouring non-Indian communities' judgment, 3) the federal government's judgment, and 4) the individual's judgment. There are obvious pitfalls involved when anyone assumes an absolute position in terms of any of these viewpoints.[1]

I would like to suggest another way of thinking about the audiences for the energies coming from Reservation X.

It is hardly controversial to say that some very different responses to contemporary aboriginal art make up its discourse. Although they cannot convincingly be separated from one another, for the sake of clarity I will identify these responses by focusing on the words and works of certain exemplary figures around whom ideas have been argued, issues have taken shape, and attitudes have formed. (This is how audiences are created.) These figures can be thought of as points of entry into a very wide discursive field, making it possible to summarize ideas that are shared or critiqued by the artists and that have coloured how their work is received. It may become evident how work is made both by artist *and* audience. These are the X factors. In algebra, X is an unknown, a variable. Used here, the X factor, the role of audience response, opens up the possibility of realizing a more complex picture of contemporary art, perhaps a liberation from oversimplification and stereotyping. So let X = audience.

WHOSE CULTURE IS IT?

More than twenty-five years ago, the Canadian writer and literary maven Margaret Atwood wrote:

> Indians and Eskimos made their only appearances in Canadian literature in books written by white writers. Thus the position of the writer in relation to the Indians and Eskimos has been much the same as his position in relation to the animals in animal stories: an imported whiteman looks at a form of natural or native life alien to himself and appropriates it for symbolic purposes. The Indians and Eskimos have rarely been considered in and for themselves; they are usually made into projections of something in the white Canadian psyche, a fear or a wish.[2]

Many novels, including Atwood's own *Surfacing*, bear her out. It has been much the same in the visual arts: witness the projections, variously awe-inspiring and tawdry, of George Catlin and Paul Kane, Edward Curtis and Jeff Wall. A slightly different spin is given to cultural belonging as measured through land by Terry Goldie, who is

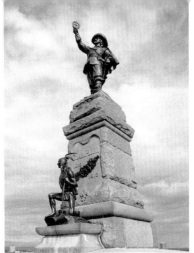

thinking of white versus aboriginal in a global sense: "Through the indigene the white character gains soul and the potential to become of the land. A quite appropriate pun is that it is only by going native that the European arrivant can become native."[3]

Although there have been more than a few cases where the learning process has been disastrously slow, even non-existent, newcomers can learn. More and more Native books and films are directed towards hybrid audiences. To some it seems possible to defend the need of immigrants to absorb the cosmology of their new land to replace what they had lost in leaving the old. Permission to do so is reported by Mike MacDonald, a video artist of Mi'Kmaq descent: "I once heard an elder say that the great crime in this land was not that the natives had their language and culture beaten out of them in boarding schools — the great crime was that the people who came here did not adopt the culture of the land."[4]

Yet the old world is not necessarily a lost world. Immigrants carry with them ideas about the communion between the earth and its human inhabitants inherited, however indirectly, from their own cultural sources. Atwood's position should relax to reflect the cultural hybridity inevitable in a nomadic world where mythologies are accumulated and reconfigured rather than replaced.

LORETTA TODD: APPROPRIATION

But some mythologies have been totally obliterated. Under the terms of an analysis informed by the grossly unequal and unethical power relations of colonialism, Atwood's allowance for accommodation seemed intolerably apolitical. By the late 1980s, the Métis film-maker Loretta Todd was, with many others, calling Atwood's account of cultural borrowing "appropriation," adding that any cultural loss suffered by immigrants was only fitting penance for their trespass. In Canada, Todd's name came to be associated with the voracious appetite of some cultures for the benefits of others. "Will they never be satisfied?" she inquired. Todd's uncompromising position helped many people to understand that power and power over knowledge are inseparable, and that greater respect should be shown for the realpolitik of cross-cultural contact.

Appropriation may take other forms. The growing appreciation for First Nations art in the post-World War II period would not be the first time that an apparently sophisticated appreciation of another culture's means of expression was able to

displace the urgent need for political action. *Arts of the Raven* at the Vancouver Art Gallery had done so in British Columbia in 1967. The modernist ideal evident in that exhibition's display of decontextualized masterpieces from the Northwest Coast is summed up by the art historian Norman Bryson: "A truly modern object is something like a Platonic form; it cannot be inflected by local ownership or idiosyncratic usage."[5] Thirty years later Todd's stand against transcultural appropriation is developed in Dana Claxton's video *Buffalo Bone China*. Here the local and the historically specific *are* the story, which shows how a material transformation — food supply to luxury item (the bone china dinner service was an elegant by-product of the extermination of the buffalo) — was really genocide. In the work, the buffalo pounding across the prairie to the clash of cymbals serves as metaphor for destruction.

Todd stands for a protective strategy, a way of limiting the audience. If knowledge is power, knowledge withheld is greater power. The precise nature of the community audience and the particular requirements that the work is fulfilling usually remain private knowledge.

SHERMAN ALEXIE: THE RESERVATION

The need to talk about the reservation is being met by a growing number of Native writers and artists. *Reservation Blues*, published in 1995, became a best seller. In *writing* the reservation, Alexie invokes Wellpinit, the Spokane reservation created in 1881, with actual as opposed to virtual geography. Virtual geographies are what federal bureaucrats in Canada and the United States seem to believe they are dealing with, as do New Agers, left-liberal sympathizers, and right-wing non-sympathizers — any of them could be the audience for a novel about reservation life.

Alexie punctures any fantasies with his gritty realism, but at a certain point deflects further inquiry by resorting to social surrealism. A social critic who believes in something else besides the need for better housing and better food, he shows that on the reservation "real" is not synonymous with what passes as normal off-reservation. Alexie achieves this by writing mythologically, blurring the real and the surreal.

Among the characters in *Reservation Blues* are non-Natives seeking expiation and Natives seeking revenge. There are those who remember the past and those who do not.

LAWRENCE PAUL YUXWELUPTUN, *ALCOHOLICS ON THE RESERVA-TION*, 1985. COURTESY OF THE ARTIST

The past survives in the person of Thomas. "Traditional Spokanes believe in rules of conduct that aren't collected into any book and have been forgotten by most of the tribe. For thousands of years the Spokanes danced, conducted conversations, and courted each other in certain ways. Most Indians don't follow those rules anymore, but Thomas made the attempt." This reservation is peopled by the wise and the foolish, but they all belong together.

The mess of the reservation, as well as its saving grace, is also found in the contradictory bright colours of the Coast Salish artist Lawrence Paul Yuxweluptun's grim pictures such as *Alcoholics on the Reservation* and *The Universe Is So Big the White Man Keeps Me on a Reservation*. The abrasive social surrealism of many of his works has annoyed traditionalists, Native and non-Native. But the artist says, "To deal with the contemporary problems that interest me I have to have a contemporary language." The paintings of the reservation, are, like Alexie's portrait of Wellpinit, reprieved by Yuxweluptun's conviction that his is a "salvation art." Both Alexie and Yuxweluptun mount an outright attack on the use of misfortunes as racial markers. There may be something of community therapy in their work, but there is more than that. If the indigenous inhabitants of the land are always pictured as the victims of colonization, of alcohol, of malnutrition, their contributions to culture, their own or anyone else's, will always need special pleading. Alexie's characters belong to a place where more is allowed for than is dreamt of in stereotyping.

Victor, the washed-up, middle-aged man who cannot find a way to let his brilliant guitar playing transform his life, relieves his own torment by tormenting Thomas. When their band, Coyote Springs, is conned into a gig in Seattle, they arrive penniless. It is Victor who answers the hotel clerk's questions:

> "And how will you be paying for your rooms?"
> "With money," Victor said. "What did you think? Seashells?"
> . . .
> "Are you guys in a band?"
> "Damn right," Victor said. "What do you think we have in these cases? Machine guns? Bows and arrows?"
> "That's why we're in Seattle. We're here to take over the whole goddamn city."[6]

They end up sleeping in their van after a supper of bologna sandwiches and Pepsi.

The power of the reservation festers in another work that stars Seattle, city of displaced dreams and people — *Day/Night* by Edgar Heap of Birds. His explanatory text says:

In the city of Seattle there are countless references to our indigenous people. They are displayed in forms that range from professional football helmets to towering totem poles which are not even of the Puget Sound region. Even the name of the city itself is another mispronounced and misinterpreted name of a native leader. Through these mis-matched references, chosen by the white man, we do not find institutionalized evidence of the *living* indigenous people.

This text also declares that "although these tribal citizens have sought refuge in the urban centers that have sprung up on Indian Territory around them, the far away rural tribal communities from which they originate hold each and everyone's memory in close and high regard."

Heap of Birds supplements Alexie's version of the Native diaspora and of the *communitas* of the reservation. Reservation lives are not so mired in unequal power relations that they are a write-off. And Alexie takes care not to make a spectacle of these lives either. He accomplishes this by setting a limit on how much can be known or understood, which is, in part, the purpose of the social surrealism.

JAMES LUNA: "CALL ME IN '93"

James Luna's wry taunt, addressed to those who decide on the fate of contemporary artists, stands here for the unsettled and unsettling relationship between the Native artist and the avant-garde. Around the time of the Columbus quincentenary in 1992, there was "a flurry of artistic and media activity around race and representation . . . words like 'multiculturalism,' 'voice' and 'access' were in currency," as Todd put it.[7] Luna was in demand, but he was shrewd enough to know that there was

JAMES LUNA, *IN MY DREAMS*, 1997. THE EXERCISE BIKE, WITH ITS SELF-PARODYING, AUDIENCE-PARODYING RIDER, IS *NOT* PEDALLING OFF INTO THE SUNSET. COURTESY OF THE ARTIST

a "use by" date attached. From the mid-1980s, in those parts of the world where such matters are debated, there seemed to be a congruence between the expressive needs of Native peoples and the inclination of art world power brokers — editors, curators, funding agencies — to pay attention. Luna's cynicism indicates an understanding of the processes whereby some art practices get legitimated and some do not, and that, no matter how worthy the cause, soon enough it seems stale.

Conventional wisdom describes contemporary art as a line of development. The line may waver, but basically there is a continuum about what constitutes meaningful and important art. This line has flirted with primitivism at various moments. It has been argued that a love affair with primitivism, defined as an idea of the wild, free, and instinctive, is what has kept modernism going.[8] But the audience for the avant-garde is only one audience among many.

Luna himself always says that his first audience is his tribe, the people who live with him on the La Jolla reservation. He has made extraordinary pieces about those people, such as *A History of the Luiseno People — Christmas 1990* (1992), which have been well received by them and also made Luna into a internationally celebrated artist. He has deftly expressed his attitude towards the needs aroused by Native art in the non-Native and skewered those needs in, for example, *Take Your Picture with a Real Indian* (1991), in the throwaway lines of his performances ("I never want to see another goddamn dreamcatcher"), and in blessing the inanity of Dean Martin as the poet laureate of the reservation in his multimedia one-man act, *In My Dreams*. A large part of Luna's production has been precisely *about* audiences and finding ways of showing one audience to another.

Luna has made his work out of the ironies of multiple audiences and avant-garde mainstream acceptance. In doing so he has clarified a predicament that he shares with all contemporary First Nations artists. The notion that art has a social purpose has been sidelined for the last two hundred years or so, while visual art has been reduced to pleasure and puzzle for the viewing classes. Western art has in fact been manipulated by, or been critical of, structures of power at every stage. Now Native artists profoundly critical of this history, whose work comes out of cultural knowledge, moral outrage, and the need to "tell," are those who are forcing the reappraisal of art categories. Nancy Mitchell has written of "the mainstream awkwardly grasping for a new commodity which is outside of their worldview."[9] The fact that the purveyors of this commodity, like Luna, position themselves in various kinds of relationships vis-à-vis their audiences is a sign of some shifts in the power relations.

First Nations artists and thinkers must contend not only with Western definitions of art but with the history of Western ways of defining their societies. Northwest Coast Art, for example, considered as generic, timeless, and anonymous, has been until very recently a product of non-Native perceptions and ideas. Here is the canon-forming Lévi-Strauss, writing in 1943:

> There is in New York a magic place where the dreams of childhood hold a rendezvous, where century-old tree trunks sing and speak, where indefinable objects watch out for the visitor. . . . Surely it will not be long before we see the collections from this part of the world moved from ethnographic to fine arts museums to take their just place amidst the antiquities of Egypt or Persia and the works of medieval Europe. For this art is not unequal to the greatest, and, in the course of the century and a half of its history that is known to us, it has shown evidence of a superior diversity and has demonstrated apparently inexhaustible talents for renewal.

Fifty years later, he replaced this influential, celebratory reading of the past with a dismissal of its present:

> The Pacific Coast Indians, whom I visited in 1974, are placing in museums — in this case of their own making — the masks and other ritual objects that were confiscated more than a half century ago and have now been returned to them at last. These objects are brought out and used during ceremonies the Indians are beginning to celebrate again. In this climate they have lost a good deal of their ancient grandeur. The potlatch, formerly a solemn occasion . . . on which rested the whole social order, has been rethought by acculturated Indians imbued with the Protestant ethic and is degenerating into a periodic exchange of little gifts to consolidate harmony within the group and to maintain friendship. Symbol: displayed next to traditional masks, some of which are among the highest creations of world sculpture, a mask of Mickey Mouse can sometimes be seen.[10]

Lévi-Strauss's disregard of the cross-cultural negotiations of the present appears to justify the critique of anthropology as capable only of recognizing authenticity in the past and inauthenticity in the present. Although not the position of all anthropologists, the legacy of this attitude persists.

JOLENE RICKARD. IN IROQUOIAN CULTURES, CORN, BEANS, AND SQUASH ARE REFERRED TO AS THE "THREE SISTERS." THE TUSCARORA COMMUNITY HOLDS ANNUAL HARVEST FESTIVALS WHERE FRIENDS AND RELATIVES COME TO BRAID CORN. JOLENE RICKARD

JOLENE RICKARD: "THE SITE OF INDIGENOUS RENEWAL IS VISUAL THOUGHT"

Rickard takes the unequivocal position that Native consciousness is different from non-Native, that there are culturally distinct epistemologies and distinct constructions of reality. "We may not have words for *art* [in Native languages] but we do have words for the things that we make." According to Rickard, the site of indigenous renewal lies in "visual thought," since Western art has separated word from object, "leaving both mute." The ways of discerning this, she says, are that there are no indigenous ways of critiquing Native by Native, and that placing borders around intellectual property is not possible. She also recognizes that her positioning is her own responsibility: "I must theorize a space for myself as a Tuscarora artist in a culturally diverse world."

Rickard speaks of Native accomplishment in the understanding of human consciousness, of an extraordinary sensitivity towards its ways of manifesting itself, and a whole vast panoply of extending, controlling, and expressing it. It is extraordinary when set against the ordinary, that is, non-Native scale. It is an accomplishment that, in her view, exceeds any Euro-American equivalent and is the defining characteristic of aboriginality on this continent. She says enough about her own experience of raising corn to indicate the delicate and passionate meaning of this ritual duty in her Iroquoian culture, but at the same time deflects what she calls "the voyeuristic inquiry into aboriginal knowledge" (both echoing Todd and sharing Alexie's distance-maintaining devices).

Rickard is proud to be descended from "the fighting Tuscarora," who set up the first site of Native resistance in North America. However, she voices the widespread need to find a pathway between a strategic essentialism, "so as not to dilute my Tuscarora-ness," and a hybridity that "everyone" can understand. Crosby regards the

balance between essentialism and hybridity as a critical
political issue, one which demands a recognition of "the
empirical reality of aboriginal people who have been his-
torically displaced from traditional lands, and recognizes
the importance and the legitimacy of the hybrid histories
that have arisen out of their displacement."[11] Rickard has
shown in her own work that some seemingly rigid Native
traditions are so by virtue of being products of eighteenth-
century colonialist practices.

BEAU DICK: "IT DOESN'T MAKE MUCH DIFFERENCE TO WHAT I DO"

One of the heated arguments in First Nations art discourse
concerns whether authenticity can be measured in terms of what and whom a work is
for. When Beau Dick carves a mask from the Kwakwaka'wakw Atlakim sequence for
a relative to wear while dancing at Alert Bay, he knows who his audience is. When he
carves another version of the same mask for his dealer in Vancouver, he exchanges
certainty for the chance of a wider and unknown audience. But it doesn't make much
difference: "they are all paying customers." He adds, "That's how it's always been. In
the olden days a carver would be commissioned when someone needed a mask to dis-
play his rights and privileges, and he would be paid in some way." Dick does admit to
having observed a difference when given short notice: "When I don't put much effort
but a lot of hurry into what I am doing, then the piece ends up with a roughness and
a kind of simplicity that reminds me of some of our treasured pieces from the eight-
eenth century."

When Yuxweluptun titles a painting *Red Man Watching White Man Trying to Fix
Hole in Sky* (the parody of colour classification, the parody of Native speech patterns,
the parody of impotent hubris is as assured as his knowing play with art styles), then
sells it to a private collector, the urgency of its public address appears to have been
blocked and the painting cheated of its function. But what if he needed the money
more than an audience?

When the Haida carver Robert Davidson was commissioned to carve a talking
stick for Pope John Paul II, it was for a papal audience of one. But it was also made for
those who want to mark the maintenance of relations with the Catholic Church and to

do so by shifting the balance of power. The Haida confer on the Pope the power to speak so the latter can no longer claim that his exercise of power is superior and fore-ordained.

These examples perhaps give some idea of the complex responses and reactions to aesthetics and identity, to rights over spiritual property and over appropriate audiences. It is clear that the denizens of Reservation X resist any single way of shaping and framing what they have to say. If, like Shelley Niro, they also happen to be artists, they are going to be wrestling with discourses of art and tribe, with traditions old, new, and invented, with finding ways to draw on old meanings while allowing for new meanings, with power struggles over memory and anger. The conflict between the recognition of extreme difference as the non-negotiable basis for identity and participation in a universalizing global culture to which all differences contribute is played out on Reservation X.

In his poem "Man and the Echo," Yeats wrote, "What do we know but that we face one another in this place?" He might seem to offer a satisfying conclusion, a simple statement of an undeniable, shared humanity. But Yeats is a Western poet, no matter how subtle and inspiring. It is up to the artists of *Reservation X* to show another way of knowing.

Notes

1 Geary Hobson, "Remembering the Earth," in *The Remembered Earth: An Anthology of Contemporary Native American Literature* (Albuquerque: University of New Mexico, 1981), 1.

2 Margaret Atwood, *Survival: A Thematic Guide to Canadian Literature* (Toronto: Anansi, 1972), 104.

3 Terry Goldie, *Fear and Temptation: The Image of the Indigene in Canadian, Australian, and New Zealand Literatures* (Kingston: McGill-Queen's University Press, 1989), 16.

4 Deborah Doxtator et al., *Revisions* (Banff: Walter Phillips Gallery, 1992), 16.

5 Norman Bryson, "The Commonplace Look," *Times Literary Supplement*, 17 October 1997, 20.

6 Both passages are from Sherman Alexie, *Reservation Blues* (New York: Warner, 1995), 134.

7 Loretta Todd, "What More Do They Want?," in *Indigena: Contemporary Native Perspectives*, edited by Gerald McMaster and Lee-Ann Martin (Vancouver: Douglas & McIntyre, 1992), 55.

8 Daniel Miller, "Primitive Art and the Necessity of Primitivism to Art," in *The Myth of Primitivism: Perspectives on Art*, edited by Susan Hiller (London: Routledge, 1991), 50-71.

9 Nancy Mitchell [Mithlo], *Art in America* 81 (1993), 23.

10 Claude Lévi-Strauss, "The Art of the Northwest Coast at the American Museum of Natural History," *Gazette des Beaux-Arts*, quoted in retranslation for *La Voie des masques*, 175-82, and "Saudades do Brasil," *New York Review of Books*, 21 December 1995, 19-21.

11 Marcia Crosby, "Nations in Urban Landscapes," in *Nations in Urban Landscapes: Faye HeavyShield, Shelley Niro, Eric Robertson* (Vancouver: Contemporary Art Gallery, 1998), 12.

LOST O'KEEFFES/MODERN PRIMITIVES:
The Culture of Native American Art

Nancy Marie Mithlo

For many, Georgia O'Keeffe symbolizes an attachment to land — specifically a South-western landscape. Her identification with New Mexico is seamless — a brilliant blue sky, the ever-present cow skull, and a sparse adobe interior all speak to what should now be termed O'Keeffe charm instead of Southwest charm. The opening of the Georgia O'Keeffe Museum in Santa Fe signaled more than the latest tourism frenzy; it represented a resounding placement of the outsider front and centre. The actor Gene Hackman, a museum board member, declared at the opening, "O'Keeffe said, 'It is my place.' Now it is even more so because of the museum." Local residents counter, "It's not O'Keeffe Country, it's our country."[1]

This latest wrestling over ownership of place is not unexpected in an arts city whose constantly fluctuating identity lends an aura of the surreal to everyday living. Local newspapers ran simultaneous articles in which O'Keeffe Museum representatives gleefully announced donations of $5 million in endowments, while the Institute of American Indian Arts (IAIA), celebrating its thirty-fifth anniversary, received notice that its federal funding for the next academic year would be cut in half with no future appropriations.

Hungry for some taste of belonging, urban refugees are fleeing to arts meccas like Santa Fe in search of a borrowed identity. In doing so, the other becomes more real than the original. In the words of Umberto Eco, we journey into areas of "hyperreality" where assurance is established through imitation.[2] In search of an authentic connection, new identities are formed through selective borrowing. The resulting icons are replacing the old originals at worrisome pace. Traditionalists are quickly becoming adept at maneuvering into the cramped spaces left available to them.

It was in this charged climate of celebration and alienation that I was invited to curate a show at the Institute of American Indian Arts Museum that would coincide with the O'Keeffe Museum's opening. Initially titled *In the Spirit of O'Keeffe*, the exhibition's premise was to show a parallel development between O'Keeffe's work and Native American arts. In the process of developing a theme, I shifted from a straight examination of landscapes to a fascination with the marketing of O'Keeffe as a type of "primitive" other whose charm resided in her "womanly" approach to modernism.[3] Like O'Keeffe, Indian artists are marketed for their perceived unconscious connection to the land, their innate spirituality and sensuality, their childlike wonder. I titled the

AFTER MONTHS OF HEAVY PROMOTION, AN ESTIMATED CROWD OF 5,000 ATTENDED THE O'KEEFFE MUSEUM OPENING, WHICH LED TOM SHARPE OF THE *ALBUQUERQUE JOURNAL* TO PEN AN ARTICLE TITLED, "GET GEORGIA OFF MY MIND" (18 JULY 1997). THE CARTOONIST JONATHAN RICHARDS OF THE *SANTA FE REPORTER* CREDITED THE ABRUPT RESIGNATION OF THE O'KEEFFE MUSEUM DIRECTOR PETER HASSRICK TO THE GENERAL FOOLISHNESS OF THE O'KEEFFE FRENZY (30 JULY 1997). JONATHAN RICHARDS

exhibition *Lost O'Keeffes — Women, Children and Other Primitives* in reference to the neglected history of Native women painters. Alumni works that had largely been "lost" in storage were exhibited for the first time in thirty years.

Reaction was mixed. First, there was the use of "primitive," a term so laden with negative connotations that it is almost taboo. Feminists complained that women were being degraded as primitives. In addition, visitors were being misled by the phrase "Lost O'Keeffes," assuming that the museum was showing O'Keeffe's works. In the first week alone, twenty angry visitors demanded a refund because of their disappointment at not seeing her canvases displayed, which led the museum to provide a disclaimer at the door.

Public reaction to a different use of O'Keeffe, a use outside of her glorification as *the* representative of the Southwest, is telling. Are Indians allowed to use Western icons? It appeared that outsiders can appropriate Native images and values, yet Indians themselves are not granted the same borrowers' privileges. Can't an Indian institution turn an inquiring gaze on the history and meaning of an East Coast transplant, or is the O'Keeffe mystique so special, so sanctified, that penetration of this image is impossible? The intent of the exhibition was lost in the city-wide mania for O'Keeffe and nothing but O'Keeffe.

What was actually exhibited was the work of four Native women artists, students at the Institute during its early "golden years," executed when they were teenagers. These visual documents of what it meant to be a young Native woman in the 1960s at an experimental Indian arts school are just a sampling of the materials hidden in the collection of the IAIA Museum. The artists — Brenda Holden (Miwok), Beverly DeCoteau-Carusona (Oneida/Chippewa), Henrietta Gomez (Taos), and Carol Lee Lazore (Paiute) — produced dynamic canvases that pulsed with a vitality O'Keeffe would have envied. Two of the artists, Holden and Gomez, met O'Keeffe when she visited the IAIA campus. While they claim not to have been directly affected by her style (the influence of IAIA instructors such as Fritz Scholder is more evident), the artists did retain an impression of O'Keeffe as a major figure in the arts — a living, breathing icon of modernism in the figure of a woman.

What is unique about the *Lost O'Keeffes* project is the similarity of circumstance these women share. All left small tribal communities to attend the Institute, then vaulted themselves into the world at large. Holden, who entered IAIA not knowing

how to read or write, earned a BFA from Cooper Union in New York City. Lazore received a BFA from the San Francisco Art Institute and a MFA from the Cranbrook Academy of Arts. Ultimately, all four returned to their homes. DeCoteau-Carusona discovered her spiritual home with the longhouse traditions. She enrolled at IAIA thirty years later to finish her Associates of Arts degree: "Advanced painting majors there were more worldly, almost urban. A lot of them did not know their language. I didn't know my traditional ways. And now I do, thank goodness. It was a really exciting time. Maybe that's one reason why I wanted to come back to IAIA, the romance of that ideal time, that balance. A new direction." After twelve years in New York City, Gomez returned to her home at Taos Pueblo to participate in ceremonial life: "It's important coming home to find your place, your space and meaning." She now produces traditional Taos-style micaceous clay ceramics. Each of these women raised families in the meantime, translating their identity as artists to their responsibility as mothers and tradition-bearers.

I often wonder about Georgia O'Keeffe's role as wife and helpmate to Alfred Stieglitz. Reading about her summers at his family's home at Lake George, New York, I get the impression that she catered to her in-laws' needs and expectations, cooking and cleaning for dozens of the Stieglitz clan. If she had had children, would she have produced as large a body of work as she did? Struggling with my own children and work, I periodically ask myself while bent over a sink full of dishes, "Does anyone care about what kind of housekeeper Georgia O'Keeffe was?" Her move to New Mexico may well have been a flight from the responsibilities she undoubtedly faced as Stieglitz's wife.

What of the lost O'Keeffes? They did not have the benefit of an Alfred Stieglitz promoting their works. Could they or would they have enjoyed a reputation similar to O'Keeffe's if they had chosen to pursue fame instead of family? Of her decision to return to traditional pottery-making, Henrietta Gomez told me, "It was a real challenge for me . . . getting back to traditional forms. I suppose if I really wanted to pursue it, I could sell my work more. But I have a moral dilemma with how I work with clay and define myself as a Taos woman."

We rarely talk about gender and ethnicity in Native arts, about careers lost, promises unfulfilled. Yet are not the actions of women who choose to devote themselves to their families more culturally appropriate than the image of the successful Indian artist today? The ruggedly handsome Indian male, bare-chested and virile, painting spiritual images for consumption by non-Natives is an invention of the market, a debased idol we now worship. Our ideals are blurred by self-declarations of "Master" status in exhibitions such as the annual "Masters of Indian Arts" show sponsored by the Southwestern Association for Indian Arts in Santa Fe. Our Indian art stars obscure the economic realities of artists sitting on blankets selling jewellery as a nine-to-five job.

A confusion exists about the purpose and intent of Indian contemporary art. Some, in an old-trading-post sort of mentality, consider all Indian art simply a commodity. Others expect each product of Native manufacture to be a spiritually imbued artifact. While the audience vacillates between the extremes of debasing Indian art as a tourist commodity and elevating it to holy status, Native artists seek to position themselves in ways that allow them enough flexibility of movement to choose their own options. Unfortunately, the Indian arts market is so entrenched and concrete in nature that the choices are limited.

LESSONS IN THE CULTURE OF ART

For the last thirty-five years, artists of Native ancestry have produced modernist-type works in a genre generally known only as contemporary Indian art. Stylistic changes, regional variations, and various schools of thought are grouped en masse under this rubric. Almost sixty years after mainstream modern art had its beginnings, Native Americans established a forum for expression outside of what was considered traditional norms. The opening of the Institute of American Indian Arts in 1962 was a beginning point of these developments in reference to the Southwest, although numerous "non-traditional" movements had taken place elsewhere to a lesser degree. These developments are poorly understood by the majority of viewers, who, depending

ALLAN HOUSER, *SEEKING HARMONY*, 1980. COURTESY OF
ALLAN HOUSER INC.

on the ideology of modernism and its emphasis on
the individual, misinterpret a body of work that is
fundamentally communal in nature.

A subjective, contextual approach to Indian arts runs counter to basic premises
of the fine arts world. Essential to an understanding of how these differences are
played out is the concept of freedom. Artists who choose to identify with a certain
community (Indian artist, Chicano artist, African-American artist) simultaneously
forfeit their perceived "freedom" by embracing a cultural identity. The word Indian
placed before the word artist triggers a response laden with stereotypes. Notions
concerning the "cultural baggage" of Native artists (as opposed to the perceived
individual freedom of their non-Native peers) invalidate Indian contemporary art from
consideration as fine art. This marginalization results in real consequences for Native
artists, especially those who wish to be included in a fine arts realm offering higher
prestige and economic payback.

Faced with this compartmentalizing, producers of Indian art are left with few
options: deny or obscure one's ethnicity (artist first, Indian second), remain as an un-
equal but acceptable "other" (I live in two worlds), or reject the fine arts agenda
completely (there is no word in my language for art). These strategies have left us with
a tired legacy of critical approaches. Publications on Indian arts typically reflect two
parallel philosophies — ethnographic description and voyeur celebration. One overly
studious, the other stubbornly simple, both are devoid of a deeper appreciation em-
bracing a holistic perspective. We celebrate, we describe, yet we fail to analyze.
Caught on the borders of any established approach, we remain rooted in the viewer's
initial fascination with the exotic.

Those seeking more substance may attempt to find similarities in the work of
other established non-Indian artists, yet rarely if ever are Indian artists seen as
innovators. Fritz Scholder's early work is typically compared with Francis Bacon's.
T.C. Cannon's paintings are seen as reminiscent of Paul Gauguin. Occasionally, one
will hear reference to Navajo sand painting techniques as an inspiration for Jackson
Pollock's work, but never do we hear of a named Indian artist influencing a non-
Native artist. The late Chiricahua Apache artist, Allan Houser, the father of contem-
porary Indian sculpture, is often compared to Henry Moore. Near the end of his
career, Houser produced several abstract works that convey the same graceful fluidity
as his figurative sculptures. His move to modernism and general acceptance in the
market was viewed as an achievement of parity in the fine arts world. Yet who do we
say was influenced by Houser's work, besides his Native American students? Are all
Native arts considered derivative because of their cultural affiliation?

ALLAN HOUSER, *APACHE GANS DANCER*, 1980. COURTESY OF ALLAN HOUSER INC.

When culture is viewed as confining, a crime against the human condition is committed. Culture does not reside solely with those who have brown skin. Values and biases are learned, opinions formed. There is no acultural setting. The irony is that those identified as fine artists (non-ethnic) cannot realistically stand outside of their culture, either. Thus, claims of having complete freedom to create as a criterion for inclusion as a valid artist are false. The freedom to create extends only as far as one's society will allow. The production of art, then, is above all a social endeavour.[4]

Various social systems, cultural groups, regions — all operate under their own individual conceptions of what is beautiful, ugly, meaningful, or trite. These multiple "art worlds" exercise their own rules of categorization, use, and aesthetic criteria.[5] For example, many land-based cultures believe that inanimate objects are alive. Spiritual objects are imbued with physical needs and emotions; they must be fed and cared for. This cultural awareness lends credibility to what Native artists have been claiming for generations: indigenous values vary from the unicultural fine arts domain that asserts its right to make so-called objective appraisals on formal qualities alone.

RACE-BASED MARKETING

The cultural barriers that marginalize Indian arts not only obscure an understanding of meaning, they also result in serious economic consequences for practising artists who desire inclusion in a global arts arena. The invalidation process that claims cultural artists are not in the same league as acultural fine artists leads to a type of economic racism that is rarely exposed. In my interviews with artists working in Santa Fe, I found a reoccurrence of "market stories" — tales of injustice and racism in the local gallery system.

Mike McCabe, a Dine artist known for his abstract print work, had just graduated from IAIA and was considering showing his work in a Santa Fe gallery. In 1991, he told me what happened:

> I went to one gallery I really liked that had very good contemporary work, and I asked, "I notice you don't have that many artists. Are you looking for other artists?" And she said, "Yes, but I don't think I'd submit my slides here." And I said "Why not?" She said,

"Well, we don't show Indian art here." She didn't even know what my work looked like.

I ended up sending slides to that gallery, but I didn't write in my resume that I had gone to the Institute of American Indian Arts. I sent them the slides and they wrote me: "Come in. We'd love to look at some more work." And of course I didn't go back there again. I just thought, here's a gallery that claims to be open-minded about art, but they're really close-minded . . . they have preconceived ideas.

This scenario is a typical "coming of age" ritual for Indian artists trying to establish themselves in a regional market. McCabe commented that these events are so common in the Indian art market that Native artists have become desensitized to their rejection; they censor themselves to fit into existing systems.

Yes, all artists struggle for acceptance, but Indian artists must cope with more challenges than other artists who present themselves as non-cultural persons. Denial of race as a factor in the assessment of Native arts is simply a blame-the-victim mentality. It is not a matter of just trying harder. The reality is that we live in a race-conscious world where all people do not have equal access to venues of power.

My family is currently in the midst of defending the artist's freedom of expression in light of racial issues. The public sculpture *Cultural Crossroads of the Americas* by Bob Haozous, my husband, was installed at the University of New Mexico (UNM) in September, 1996, as an Art in Public Places work. Funded by the state of New Mexico and the City of Albuquerque, UNM exercises legal right of ownership. The artist's addition of a string of coiled barbed wire across the top of the billboard-like steel monument raised the objection of a small ad-hoc university committee who perceived that a negative message was being sent to the public about cultural harmony. They will not pay for the sculpture until the wire is removed, citing breech of contract. Haozous refuses to remove the wire, citing his contractual right to make minor changes to the original maquette as he sees fit. The case is in the court system.

This example brings up many questions concerning not only the production but the regulation of cultural arts. Would the addition of barbed wire be perceived as menacing if a cowboy artist had produced the work? Coiled barbed wire has historical significance for our tribe of Apaches in Oklahoma. The material was used to encase us during our twenty-eight years of captivity as prisoners of war. We also relied on similar wire while raising cattle at Fort Sill, a successful tribal business. The university art officials, however, associate the "razor wire" with hostility and menacing barriers. Obviously, two very different interpretations of the material are at play. UNM perceives that an Indian man is turning a white man's tool of control against him. The artist asserts that the medium is innocuous; he sees *Cultural Crossroads* as a positive message about people transcending the borders that separate them.

The category of public art and public funding raises the market issue to another level of debate. Certainly one of the functions of public art is to be responsive to a

BOB HAOZOUS, *CULTURAL CROSSROADS OF THE AMERICAS*, 1996. KAY WHITNEY OBSERVES, "HAOZOUS' GREAT ACCOMPLISHMENT IS THAT HE IS ABLE TO WITHSTAND THE PSYCHIC STRAIN OF HIS DOUBLED SENSIBILITY, SUSTAIN HIS DUALITY, AND RESIST THE HARSH PRESSURES OF A MODERNITY WHICH DEMANDS REJECTION AND ALIENATION FROM ORIGINS" ("DOUBLING BACK," *SCULPTURE,* 7 APRIL 1997). COURTESY OF BOB HAOZOUS

larger community. Most public art controversies involve a popular outcry against the work. This is not the situation with *Cultural Crossroads*. The city of Albuquerque wants the work to stay; UNM students want the work to stay; and the sculpture received overwhelming support at a city-sponsored public forum.

To draw a parallel with the arguments presented earlier, the work is a social product. In fact, for the first time in a long time, Hispanics and Indians (the state's official minorities) are working together to address the issue of censorship in the arts. Although some caution that this legal fight will jeopardize the future of an already frail public arts funding support base, other consequences seem more dire. What if the artist were to take the wire down and accept the money? Wouldn't this send the message that Indian art is only decorative after all — that our cultures are commodities? Along with performance art, public arts may be one of the few spaces available for Native artists to express their culture without censure. Haozous comments, "It is absolutely essential to remain honest — either that or make coffee cups and T-shirts."

I believe historians will look back at the end of this millennium as a time of great confusion. Cultural boundaries are blurred, cross-cultural appropriations are rampant, tribes struggle to reclaim and define what is theirs, while economic interests push us further into the marketplace. Our art heroes, like Georgia O'Keeffe, are recluses, runaways who adopted an alter-identity the quickest and easiest way — by moving to the American West. While Native artists are studiously influenced by modernism, their non-Native contemporary art peers drop further into the reaches of conceptual arts. A total lack of communication exists between fine arts ideologies and Indian art aesthetics. It is difficult to imagine how to find a common ground when so many of the questions raised here appear to have no relevance to the larger international art community.

Recent exceptions to this separation are hopeful. For two consecutive seasons, the Venice Biennale has exhibited the works of indigenous artists. Canada sent Edward Poitras in 1995, and Australia chose three Aboriginal women (Judy Watson, Emily Kame Kngwarreye, and Yvonne Koolmatrie) for its pavilion in 1997. Robert Colescott was the first African-American to represent the United States the same year. These events are promising, but the question remains, must Native artists leave their cultures at the doors of these institutions, or can they enter with their cultures intact? Will there be a return to a culturally relevant arts movement, or will we have another decade or two of obscure modernism?

Considering the great number of misconceptions about contemporary Native American life in general, we must ask ourselves whether simply exposing our art to a broader audience will result in some grand recognition of Native intelligence. What could motivate a population under the delusion that Native people are cigar store Indians, to be used only as props for the real business inside? It appears that the audience wants it both ways. If, for example, a Native artist exhibits at the Biennale, the expectation will be that the work must "look" Indian or it is not authentic. If the work looks too culturally based, however, then its status as fine art will be questioned. If the work is devoid of any reference to a tribal mentality, does it cease to be Indian art? Would it then be viewed as inauthentic?

Authenticity is the main concern. Georgia O'Keeffe must have sensed the potency that accompanies an attachment to land, history, and community. She gained these things for herself by claiming the Southwest landscape as her own. Where she got it wrong was her implicit investment in the myth-making process. The lone artist, separate from society, finds truth in the wilderness — the vision quest revisited. O'Keeffe's legacy follows this pattern of self-imposed isolation.

An understanding of the harm this separateness generates can be gained by studying our generation's cold-shoulder approach to the arts in general. The arts cannot survive long under the present conservative political climate that views arts activities outside the classroom as elitist exercises in which a few privileged people talk to a few privileged people. Our art has ceased to be relevant to our world. Caught up in the desire to please, to entertain, art producers are simply handmaids to an out-of-control entertainment industry.

Here is the point at which indigenous thinkers, art practitioners, and creators may find their contributions welcomed. It is simply not that Indian people are "natural" artists, as some claim (as racist an assumption as claiming that all black people are good dancers). The value in an unencumbered expression of Native thought is its honesty, passion, and sense of a larger community. These values are particularly evident in the works of Native women. Listening to how these women conceptualize their role as Native artists, it becomes apparent that emotions and place are critical components of an understanding of indigenous aesthetics. In 1991, the Santa Clara artist Roxanne Swentzell observed to me, "In Western culture, if life gets to be a struggle, you just pack up and move. The traditional cultures are so tied to a spot and a family that you can't leave. Whenever you're hit with a problem, you're going to have to go through it because there's nowhere else to go. You are at the centre of the world" (interview, 1991).

A sense of place is a rare commodity these days, with extended families living in separate states and job markets that demand mobility. As technology promises to bring us closer together, we find ourselves drawn to the convenience of living vicariously through films, television, and the Internet. The raw passion of life is further beyond our reach, mainly because we have come to fear the unexpected. The Native arts expose this gutsy level of emotions through honest portrayals of lived experience — the loss of one's home, the trauma of historic genocide, the everyday violence that often accompanies poverty and racism. Mateo Romero's painting series *Tales of Ordinary Violence* (1996) is an example of this exposure. Beverly DeCoteau-Carusona commented to me, "Many artists are led by passion. We can't be removed from it because it's so much a part of us. Passion, anger, happiness. I don't think it's a lifestyle of neutrality for a lot of Indians. There's a lot of passion in Native American art."

It is this emotional pull, this encounter with the real that entices modern primitives to this desert landscape. Hesitant to fully relinquish power, uncomfortable with being a guest in another's home, these visitors insist on having it their way at the expense of the land's lifeblood — its people. The Institute of American Indian Arts is seemingly on its deathbed, while wealthy new art patrons have amassed millions in glorification of Georgia O'Keeffe.

Although I like the coolness of O'Keeffe's canvases, and I admire her ability to run with the big boys, I would be insincere if I joined the mass celebration of her ascension to art museum fame. My maternal instincts direct my attention instead to

the wounded but still breathing Native arts community. If, as some believe, it takes a village to raise a child, then Santa Fe is destined to feel the interconnectedness between the frenzied excitement of the newly arrived and the pain of those still exiled on the margins of acceptance.

After all, O'Keeffe is only a figure, a popular icon, some may even say a fad, who happens to have found fame after years of rejection herself. Optimists will rally: "Yes! A woman artist of substance arrives!" Realists will caution, "She's dead, she's from the East, and her work was, after all, modern and decorative." Looking towards the future of Indian arts in the Southwest, I optimistically envision recognition and admiration for Native women whose stories have been buried by years of neglect. Realistically, I wonder: will they say it's authentic?

Notes

1 William A. MacNeil, *Albuquerque Journal*, 18 July 1997; Bruno Navarro, *Santa Fe New Mexican*, 13 July 1997.

2 Umberto Eco, *Travels in Hyperreality* (Orlando: Harcourt Brace, 1986), 57.

3 Barbara Buhler Lynes, *O'Keeffe, Stieglitz and the Critics, 1916-1929* (Chicago: University of Chicago, 1991), 9.

4 Thomas McEvilley, *Art and Otherness: Crisis in Cultural Identity* (Kingston NY: McPherson, 1992), 19-20; Janet Wolff, *The Social Production of Art* (London: Macmillan, 1981), 118-19.

5 Howard Saul Becker, *Art Worlds* (Berkeley: University of California, 1982), 34-35.

MARY LONGMAN
STRATA AND ROUTES

NEAR GORDON RESERVE. DARYL DREW

MARY LONGMAN: STRATA AND ROUTES

THERE IS NO FIXED ADDRESS FOR RESERVATION X
GERALD McMASTER

Mary Longman summarizes the spirit that "there is no fixed address for Reservation X": it is everywhere and nowhere.

Born on the Gordon Indian Reserve in Saskatchewan, Longman was fostered out at a young age, and when she was fifteen she was reunited with her original family. She continued living on the Prairies until the early 1980s, when she left to pursue a career in art, studying at the Emily Carr College of Art and Design in Vancouver, then at Concordia University in Montreal and the Nova Scotia College of Art and Design in Halifax. She has recently enrolled in a PhD program at the University of Victoria. Before arriving in Victoria, she taught at the Nicola Valley Institute of Technology in Merritt, British Columbia, and she lived on the Shackan Indian Reserve from fall 1993 to summer 1997. This ancestral home of the Nle?kepmx people is known for its many ancient pictographs. Shackan became Longman's second family.

In a world that has become increasingly atomized and a world that grows ever smaller, we have become disoriented, disconnected, and displaced, forever trying to make sense of place in an increasingly complex environment. Who is our community when our network of relations live in spaces subdivided into cities, towns, reserves, neighbourhoods, blocks, and houses? At first glance our social space is our friends and neighbours. Longman chooses to say it is family and home that bind her to place; then, community. But what is community for her or for most aboriginal people?

While the connection to community often signifies continuity, other connections, which are beyond community, come from deep within her personal life. Drawing on customs and traditions is not only a bond; she adapts them to contemporary everyday life.

How does Longman conceptualize these frequent shifts in and outside Reservation X? Her recent works derive their foundation, in part, from a profound consciousness of her aboriginality, paired with the quotidian experiences in and outside aboriginal communities. The piece called *Reservations*, for example, pertains to the tenacity of cultural memory. Atop the decorative base of a column sits a birdcage; in it stands a solitary "tree of life." The rusty and decaying cage constructs a confined space for its inhabitant. It symbolizes a once strong "system," now falling apart, unable to assert its authority in containing aboriginal cultures. The birdcage is solemn-looking, yet it is able to maintain a tree. The sturdy column refers to the government controls of Canada

SHACKAN INDIAN RESERVE, LOWER NICOLA VALLEY, BRITISH COLUMBIA. MARY LONGMAN

and the United States over aboriginal peoples as subjectivity. It is an externally imposed system that denied the consensual pattern that most aboriginal tribes had before European contact.

This work refers to the tenacity of cultural memory. Reservations hold significant stories. Anyone raised on one often experiences a profound sense of ambivalence: love and hate, attraction and repulsion, freedom and confinement, liberty and subjection. The reservation is a life in constant transformation.

This work does not force itself upon us politically; there is a far more subtle evocation of the principles of rationalism as evidenced by the containment of a small plant (tree), which signifies the colonized. We begin to realize that humans are the rational animals, capable of containing nature. The leaves, however, manage to escape their confinement. But, like a colonized people, they can be clipped and controlled — maintained, managed, and manicured. Interestingly, the plant's roots — tradition, ancestry, history — remain within the boundaries of the cage. While the plant's life can be terminated at any time, its independence is always in question and under surveillance. Why then can't it grow and become something? This question, in fact, forms the new discursive debate for aboriginal leaders who are attempting to define their idea of self-determination through self-government. We may see the plant as a people or community taking a step towards this self-determination, of wrestling authority away from the government's Department of Indian Affairs, the Great Modernist Project. Indeed, this radical move to rebuild local identity is occurring in many aboriginal communities today. At the same time, we are witnessing a system that

is losing control and is no longer instrumental in the everyday life of aboriginal communities, a system that can provide only economic, not cultural, welfare.

The tension in Longman's installation *Medicine People* signifies a simultaneity of push/pull, active/passive, us/them, known/unknown, a striving for balanced relationships. Abstracted shapes of the buffalo-horned headdress turn toward each other, supporting an object by their spiritual power. Copper wires, suspending a round object, suggest the healing process conducted by medicine people: their passivity keeps a vulnerable rock afloat. This intimate, private, and powerful circle confines viewer participation to a minimum. Medicine people were not considered doctors who, in the contemporary sense, gathered round to resolve issues based on observing symptoms. Rather, they were a special group concerned more with psychological manifestations and the origins of sickness. Medicine people have special powers and a language that make them almost incomprehensible. Longman articulates these concepts in many ways. Looking at this work, however, suggests more questions than answers. The three horns personify three figures, or holy people, engaged in a mutual ceremony. Are they gathered around an embryonic form or rock to help give it energy and spiritual strength? This isn't clear. It seems, however, that this gathering of medicine people is not by chance but by design. The coming together is more in the realm of resolving a problem, or in honour of an event of extraordinary meaning.

Strata and Routes is a sculptural installation that shows two tree trunks with roots sprouting at each end. Longman was inspired by a little rock she saw embedded in an overturned tree. That sight gave rise to this work, in which she expresses relationships, identity, and community. How does a tree grow to be this way? The image is trompe l'oeil; there is only a suggestion that it grows this way. The two trees are positioned together, layers (strata) of little rocks repositioned at the centre acting as sutures. A large stone, supporting photo-emulsified images of her biological family, is embedded atop the trunk with the roots growing around it. It is a deceptively simple work, yet powerfully overdetermined, in that it is an intensely personal statement about Longman's heritage, firmament, and progression.

Strata and Routes pieces together home, family, and community. Although her work is strongly influenced by aboriginal sensibilities, her themes are clearly

decipherable: family and community communicate universally. (Shackan, which means "little rocks," became Longman's second family.) In this piece we see the value of community and personal growth as affirming self-determination among First Nations. Her use of a tree, as in *Reservations*, signifies the bond with family and nature, that nature as suture helps heal First Nation communities. Roots reach into the earth, suggesting heritage. Roots also reach into the skyworld, cradling the images of her family. The homophones *routes* and *roots* are resonant. Perhaps Longman wants us to know that we follow many paths, yet we will always find home.

MARY LONGMAN SPEAKS . . .

On community: Community is a complex idea. To look at any community you have to examine the identities that make up the community — personal and collective identities. What makes up identity? What makes up that lineage, past conditioning, learned experience, and the decisions you make in life? Collective identity consists of activities you share in the environment you live in. I started asking, "What do we all do that's similar?" We live in mountain terrain and along the river. We go fishing and horseback riding and collect plants in the hills, like Labrador tea and rose hips for medicines.

On contributing to community: You can't really separate yourself from your roots. It's important for everyone to go back to where they're from. I spend every summer on both the reserve and in the city, because my family lives in both places. In the summer, the reserve hosts many ceremonies like sundances and giveaways. It gives me the opportunity to partake in those activities and spend time with relatives. I think this is reflected in the artwork I do. Some of my content focuses on my family and experiences. Other works focus on where I live now. I am documenting those traces of my life experiences. At the same time, I'm retaining traditional philosophies and values as I work through contemporary media. There's a certain responsibility for artists in contributing to their community. But there's also a constant struggle in what you're doing. What audience are you going to do this work for? I try to do it for both. Being in an aboriginal community is important to me because I can contribute, like our ancestors did. This is why I am teaching. I have gone away to learn, now I will recycle the information by giving it back to the community — through education, hiring apprentices, or a young guy to mow my lawn. It is important for me to share what I have.

On identity: In the beginning I looked for a blanket statement about identity, but I realized that that wasn't possible. I decided to look at diversity and figure out a way to portray that. I ended up thinking about two main aspects that influence identity: the physical environment and learned experiences. My ancestral roots are on the Gordon Reserve, Saskatchewan. I have lived in almost every province in Canada and in the Arctic. So how do I define this nomadic, diverse identity? Perhaps it is not to be defined in one clean sentence, but rather it is an exploration of nomadism leading to a hybrid of many sorts.

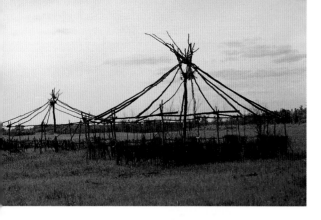

On stereotypes: It doesn't matter where you live, what you dress like, or what your beliefs are, if you're Native, you're Native! That's all. You don't have to prove anything to anybody. You don't have to fall into any kind of stereotype.

On the city: For an artist, the city is a good place to be for interaction. It is something I miss, being out here in Merritt. You are starved for communication. But I feel that the city is unstable. You don't notice, until you move away, how you change as a person. Since I moved away from the city, people often say, "You're so calm. What is wrong with you?"

On the reserve: The reserve is a place I can go back to. I'm not worried about anybody judging me or not accepting me for who I am. It is a place to go for peace. It is a place to learn. Being born on the reserve, having my family move to the city, going into a foster home, reconnecting with my family, going to university, and travelling across the country — I got to know a lot about different cultures across Canada, particularly First Nations cultures. In the end I came back to a reserve other than my own. Teaching within in a predominantly aboriginal community is where I feel most comfortable. It's where I would like to stay.

On family: I enjoy visiting my family. I miss them, I want to see them, I want to laugh and joke around. I want to reconnect. Half of them live in the city, the other half live on the reserve. Reconnecting makes me feel proud to be with my family. It is not a process of finding my identity, asking: Who am I? Where do I belong? I did that early search, now it is just a continued learning process of going through life.

On the community of Shackan: Shackan is a central place for pictographs. Local people are interested in trying to find traditional art forms, ones they feel have slipped away, and are trying to retain or revive them. Recently, I was asked to do some interior design in a band hall for one of the neighbouring reserves. I decided to get as much information as I could on all the pictographs in the immediate area and reproduce them on a large scale in the Council Chambers. I wanted to help revive interest and remind them not to forget about their heritage and ancestral art.

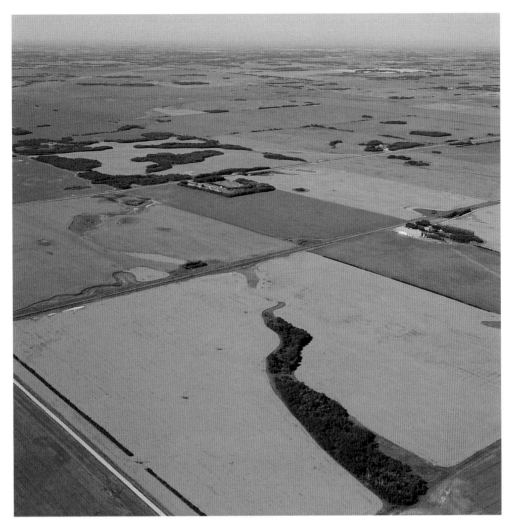

NEAR PUNNICHY AND FORT QU'APPELLE, SASKATCHEWAN. DON HALL

On *Strata and Routes*: The work evolved from my examination of identity and place. Identity is a complex issue, so I began to analyze the factors that shape identity, beginning with ancestral roots and past conditioning to life experiences. Through layering of experiences over time, identity perpetually evolves. External influences play a large role in determining lifestyle, activities, and life choices. The environment shapes us, and we can also shape the environment. This is how I developed my first metaphorical image for the project. On one of my walks on Shackan, I saw an overturned tree with a large rock embedded in the roots. They lived together, grew together, and shaped each other. For some Native people, to look at a tree is to see the tree of life. They see the leaves as the individuals, the roots as lineage. I thought about this relationship and the connections of the roots.

I pondered these things, and they fit perfectly with my idea of identity and past

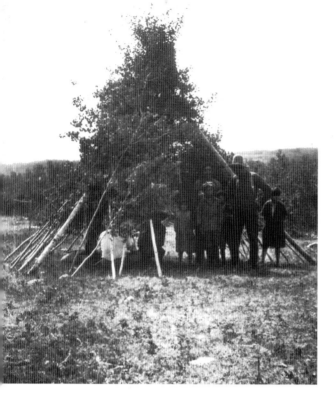

conditions. For me, the stones and rocks are a metaphor for diverse identities and how they are shaped by external influences. And because the Nle?kepmx people call this reserve Shackan, or "little rocks," it seemed to work hand in hand. This led me to think about strata in a soil profile. The layers suggested time, the evolution of past to present. The strata also become layers of memories and experiences. The tree trunks, which I searched for for many months, became one hybrid form. The roots of ancestry evolved into routes of life passages. The dangling, tiny end roots on the top trunk indicate a further growing, as if they were delicate nerve endings waiting to experience. Nestled within the top tree trunk is a large rock, which has a photographic image of my family. This is one aspect of my life that is central and consistent, and it is here where I truly understand my sense of being and place.

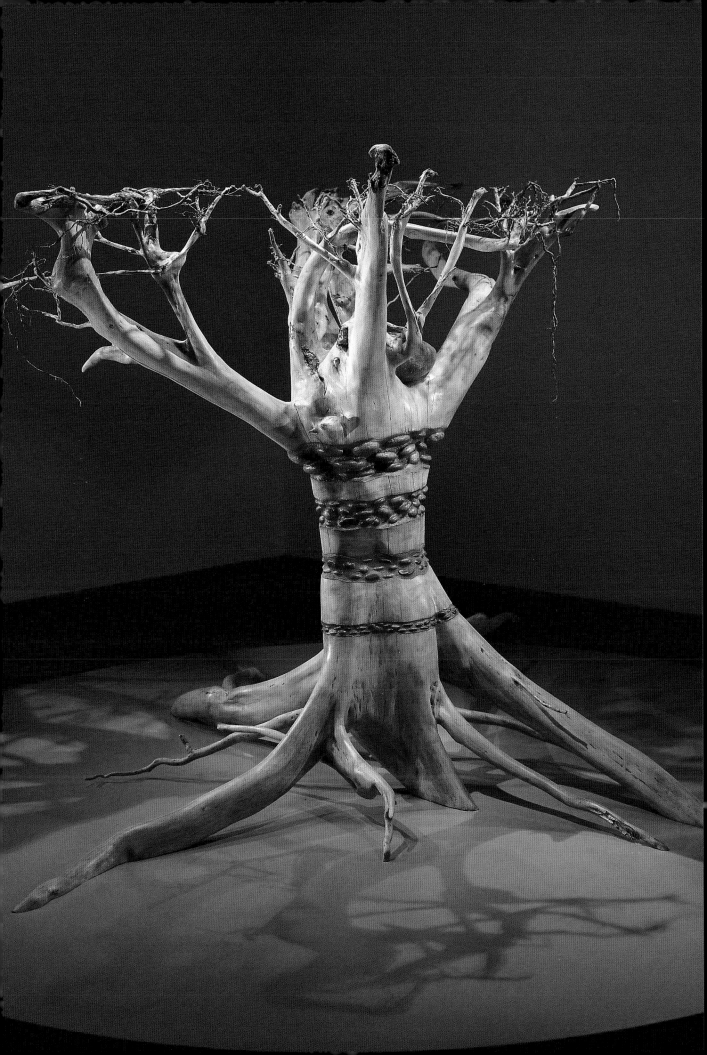

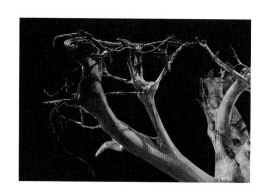

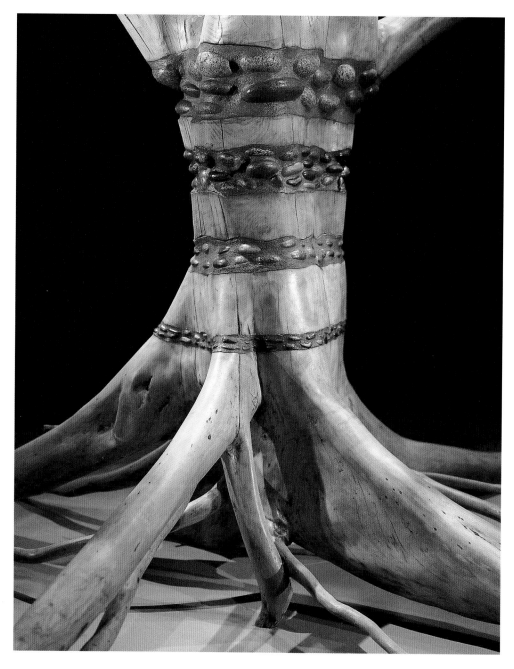

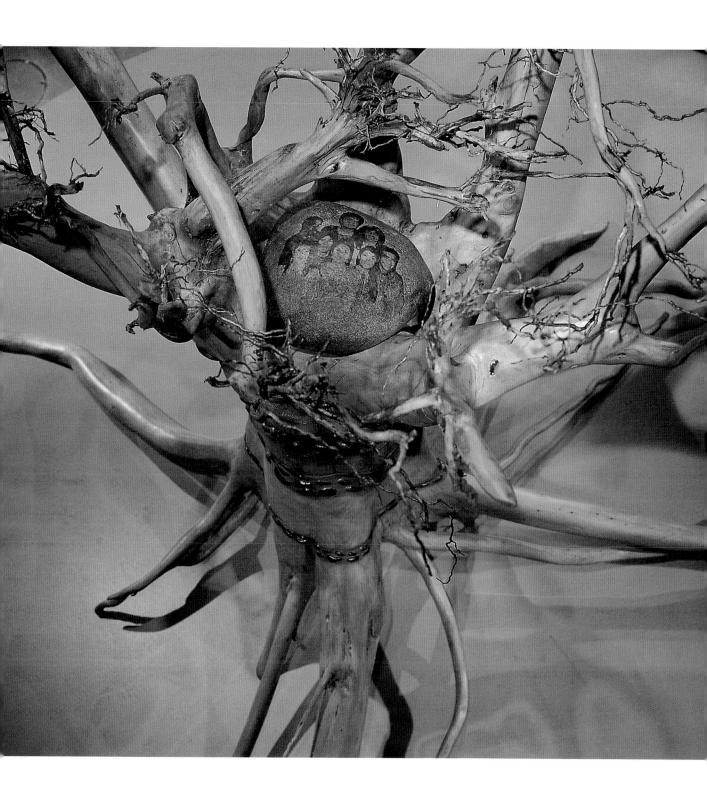

NORA NARANJO-MORSE

GIA'S SONG

FORMAN HANNA, ARIZONA STATE MUSEUM, UNIVERSITY OF ARIZONA (33555)

NORA NARANJO-MORSE: GIA'S SONG

ON AN ORDINARY DAY
NANCY MARIE MITHLO

Like the artist herself, Nora Naranjo-Morse's recent installations are a composite of varied influences — organic and polyester, peeved but proud, a little nostalgic yet contemporary. Her simplistically complex messages are delivered to the viewer with no apologies. Naranjo-Morse's solid ground allows all this tangled movement to happen without overdue concern for dropped metaphors or slipped allusions. She is a patient educator, determined to witness the trauma inherent in contemporary living. Her message is far from grim, however. She maintains that within us there is a beauty and tranquillity in belonging, which can be had by anyone "on an ordinary day." A sense of community, the magic that so many seek in Native cultures, is found simply in the consciousness of self.

Her themes include a parody of collective human attributes, the celebration of ordinary visions, a concern with modernity's all-pervasive influences, and the importance of living consciously with community. In her own community of Santa Clara Pueblo in northern New Mexico, these influences are felt on an immediate, personal level. Now in her mid-forties, Naranjo-Morse uses herself as a bridge to interpret the changes wrought at Santa Clara from the early 1950s to the present. Her experience is a reminder; her works are the evidence of a passage from self-sufficiency and equal distribution of power to a system based on imbalances of male/female, have/have not. These appraisals are so dead on centre that their potency cannot be denied.

Naranjo-Morse's early influences include her father — a man known for his ability to make, construct, build something beautiful from little or nothing. This talent in "cultivating a space to make it more pleasing" formed a connection between her family and the larger pueblo community, for his services were called upon often. Her participation taught her the importance of reciprocity and togetherness. At the same time, her own "cultivation" skills that would later be applied to clay were being trained.

As Santa Clara's subsistence farming changed to a wage-based economy and members of the pueblo more frequently married outsiders, the early worldviews she learned became jeopardized. A culmination of this process was the introduction of government-sponsored housing projects, which exchanged previous communal-based housing for isolated single-family dwellings. This development coincided with the tribal council's reflecting more governmental characteristics instead of religious foundations. The whole became "diluted." It was a "new game."

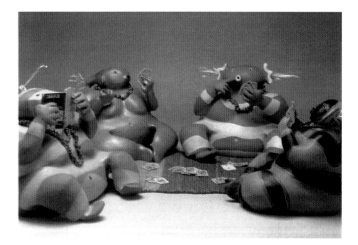

Naranjo-Morse's reflections on these transformations are infused with a sense of womanness — a fierce determination to salvage the power of self-knowledge and "living with good thoughts" for her children, who "will have a completely different sense of community than I did." Her goal is not that of a purist — she recognizes that much cannot be altered and traditions never stay the same. It is the act of thinking independently that concerns her:

> The sentiment at the time was to get Indians to be a part of the mainstream, to be dependent, to be consumers. When you're farming, when you're building, you think. You have to think! And the most dangerous thing for those directing masses of people is to have too many people thinking. To have women think? Oh, god! To have children start thinking about how to build their own home, how to cultivate their own space, how to cultivate themselves?
>
> I think the people in the know knew that the system of the Tewas was an incredible organization because it was holistic. It encompassed religion. It encompassed the economy. It encompassed everything. I think it worked so well that it was very frightening and thus needed to be marginalized.

Despite her obvious appraisal of colonialist tactics in her own backyard, Naranjo-Morse's politics are not overt in her artwork. Much is said with humour and a readiness to present herself as a case study. This deflective critique "softens the blow" for members of her own community who may find such appraisals offensive. Personalization and fictionalized characterization of community dynamics allow Naranjo-Morse a measure of freedom in identifying key elements that concern her. Identity, gender, economics, and Westernization can then be safely discussed. Her *Pearlene* series of ceramic figures illustrates this tendency vividly. Misunderstood and rejected by her community for her boldness and spirit, Pearlene in her makeup and heels is a tragic figure seen by the gossiping matriarchs as a "pitiful example of a Pueblo woman." Yet

these same women long for Pearlene's freedom, even as it carries the price of alienation and just plain hard living. Actively involved in Pearlene's saga, Naranjo-Morse crafted a man for her and then drove the two of them to their buyer, declaring the series finished. "This was the last Pearlene I did. And because she was the last one, I made her a man . . . someone who would love her unconditionally." It is this belief in the magic of creation and a determination to remain outside the grasp of a consumer-driven market that identifies her work as a process-oriented task. She not only inhabits her own artistic spaces, she also directs the dramatization according to her own needs. A self-sufficiency is evident in this process, which mirrors the larger cultural values Naranjo-Morse champions.

The move to installation works reflects this directionality towards an independence from constraint. Installation as a medium is still a fairly new development for Native American artists, and Naranjo-Morse has adeptly adopted the scene-setting process to illustrate similar themes of complex identity, feminine strength, and incorporation of the new into Native thought processes. Her multimedia installation *A Pueblo Woman's Clothesline* (from the exhibition *Watchful Eyes*, Heard Museum, 1994) is a compilation of diverse clues to the artist's identity. Embroidered ceremonial attire, a brilliant blue bra, and a denim shirt hang with other evidence of a contemporary Native woman's life in direct analogy to the real thing. But her message is more complex than a simple prop staged in a museum setting. Naranjo-Morse's willingness to be the conductor of our thoughts is apparent in the reference to her body's carrying the signposts she has prepared for the viewer. As she says in the exhibition catalogue, she is like "other hard-working women who have made the same curve in their backs as I, lifting crying children, drying adobes and wet clothing. I am the clothesline. The clothesline is me, weathered by years and circumstance."

This willingness to use her own life as illustration is continued in her work for *Reservation X*. The move from owner-built, communal adobe structures to prefab, separate government housing units at Santa Clara Pueblo is the basis of the installation. "Most of these project homes are poorly executed and built. Many of them are vacated because they are not suitable for living. I took inspiration from this image to create a mock project home in *Gia's Song*. . . . I want to educate about structure — how structures of thought conflict and how we are jeopardized by a new structure of housing. I created two sides of a wall. One side is the reservation I know. It's organic.

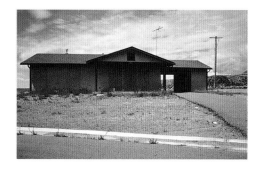

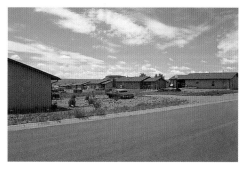

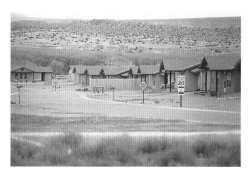

The exterior wall is manufactured. It's what I grew up seeing happening to our housing."

The fact that Santa Clara's Tewa worldview of building houses from the earth, a value system that served its people for hundreds of years, was eclipsed in a single agreement the tribe entered into with the government haunts Naranjo-Morse.

I want us to take responsibility for what we've done, the part we are playing in our lives as contemporary Native people. I think it's really easy for Native people to get angry because we have been victimized by the dominant culture, angry because we've become assimilated. We're at a very important place, the end of this millennium. We have the opportunity to begin thinking communally about what is best for our people. And that's why I'm so excited about this exhibition — it's part of what the community is to me now. That is, what part are we as Natives playing in creating a new world for ourselves?

Naranjo-Morse's role as an independent thinker is informed by this process of pulling together varied components of modern Tewa life to form a whole: an organic metaphor encompassing both beauty and loss. Her work unifies that which lies almost unconsciously in pieces on our collective landscape. She builds these unassociated influences, block by block, until a pleasing totality emerges. The conflicting value systems that many bemoan then serve as a tool to gain self-knowledge. Cultivation of space infers that there be a plan. Naranjo-Morse's installations suggest that the wholeness attracting outsiders to Native culture is also within their own reach. Simple, ordinary visions — the earth and mud that become a pot or a house, a garden grown from seeds — all become a celebration of life. This magical sense of belonging can be had on any ordinary day. You need only know yourself well enough to trust your own thoughts.

NORA NARANJO-MORSE SPEAKS . . .

On identity and truth: Most of my life I have been expected to be Native American, to act according to expectation. Once when I was getting ready for a show I was thrown into a less familiar setting with people expecting me to be an "Indian." What does that mean to contemporary Native peoples? Now I feel that it's very important to be true to who I am and to separate myself from the demands or expectations of the art market. I want to see who I am as a Native woman, as a human being, as a collection of influences, cultural and social. To me that's what's true. Art is a process of finding truth.

On keeping connection with your work: One hundred years ago, the pottery my great-grandmother made stayed in the village. When she died, the pots went to her daughter and then to her daughter and then to her daughter. People in the village always knew that pots made by their grandmothers would be part of their life. But because of the commodification of pottery, the pots made by our grandmothers began to leave the village. When I sell a piece, I ask the buyers to send me a photograph of where my creation ends up, because I still want to have that connection. So in a sense the boundary of the village just gets larger.

On objects: Objects are alive. That is basic to our worldview. I am always comforted, knowing that it is a very spiritual thing to have. It is a gift knowing that rocks, trees, clouds passing above are alive. We carry this worldview into the rest of our lives.

On building her own home: Before building my house I had a very limited view of myself in relationship to the world, this earth, the culture, everything. It was a challenge creating a very large vessel that I and my family would live in. During that process I started realizing what art is; art could be everything and is everything. When I started plastering the walls, I felt like I had been doing it all my life. An element inside of me, gifted to me by the old people, gave me the power to plaster walls for hours. This reconnected me to the culture in an important sense.

We took five to six years to build our house, using fifty-five hundred adobes, layering them one at a time. Not only was it work-intensive, it made me appreciate the whole process of constructing. I never walk into a building and take it for granted anymore.

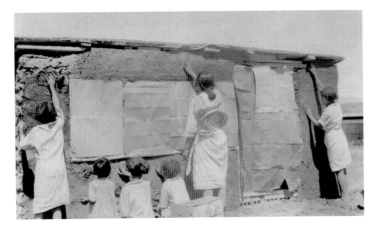

On passing on tradition: My father had the gift of fixing and building just about anything. He specialized in adobe construction. By the time I was old enough to help, I was involved in the process. The ideas I have about the appreciation of building and constructing my art come from him. My mother was a potter. She taught me about internal balance. This balance comes from knowing yourself and knowing where you belong.

When we built our house, our children saw family members come by and unload adobes. They saw their mother and father plastering. One day when we drove by Santa Clara Pueblo, we saw the government-built HUD [Housing and Urban Development] houses. The first thing my son said was, "Where is the mud?" When he said that, I could not control the tears. I realized we had put him in a unique position to understand something very elemental about himself and his relationship with his family and the culture.

On her community: My tribe is the Santa Clara Pueblo, but in the Tewa language we are called Towa. I live on the reservation, which is about 48,000 acres, but outside the village itself. The main part of the village is still unpaved and has traditional housing made of adobe and mud. On the outskirts there are framed stuccoed houses, which were built by HUD in the early 1970s.

On being part of the community: I come from Pueblo people who still have an ideology of community and what community does. Because of the choices I have made, I live on the periphery. I don't know if people who live in the community understand that I am learning how to be a contemporary Native woman. What they do understand is that I make really good chili. And that I had not one, but two children. To be a mother, a nurturer, is how I'm valued by my people. It has nothing to do with what you've achieved in the outside world, or what your name is. When my son was dancing for the Deer Dance, I made a whole feast where I fed about one hundred people. I felt I was a very important person — even though I was slaving over the stove. Maybe feminists would deem this a step backwards, but I had a role in my community. I was happy because I was nourishing my son through his spiritual journey, and, on a different level, I was being nourished through his dance and his energy.

On building a better community: Historically, Pueblo people carried the idea of community living, but because of assimilation they are becoming more fragmented.

Santa Clara now has about two thousand people. Half of them work with clay in some way or another, so the tradition of working with mud is still very important. Ceremonies still take place. Clans still exist. The young people are being taught the Tewa language because people realize we are losing it. We're also dealing with what kind of legacy we're leaving our children. There's alcoholism. I've heard of gangs and drugs. As we approach the new millennium we have a great opportunity as a people to re-create our community. Creating in the sense of making our own homes, creating gardens and safe places for our children. Creating libraries and places where old people can gather and talk to children. We need to really look at how we are creating community as a whole.

On adobe: Traditional houses were made of compacted mud, straw, and sand called adobe. They are eleven by six by eight inches and weigh about thirty-five pounds. They were used primarily to build homes, outdoor bread ovens, and interior fireplaces. Not only was this a practical way of using the environment to build shelter, but it was and still is our connection to the earth. Our culture built its belief system to a great degree on the environment, including the idea that we emerged from the earth. This idea is still very rooted in people like me who insist on building their own homes.

On the power of clay: When my mother gathered clay, she would take me with her. Before she allowed us to gather clay, we would kneel down and pray to the clay spirit, which in Tewa language is *Nan chu kwee jo*. That says volumes about our relationship to the earth. How alive the earth is, knowing that we actually have a name for her!

My mother was making a connection to something very powerful. It's very symbolic to gather clay after saying these words and knowing that our people believe they came out of the earth: that was my sense of community. And that is what I want to impart to my children.

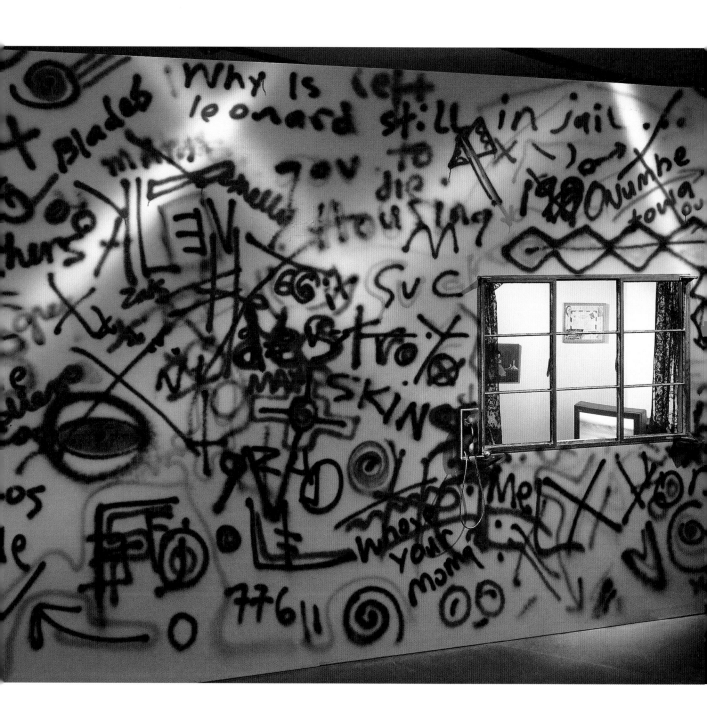

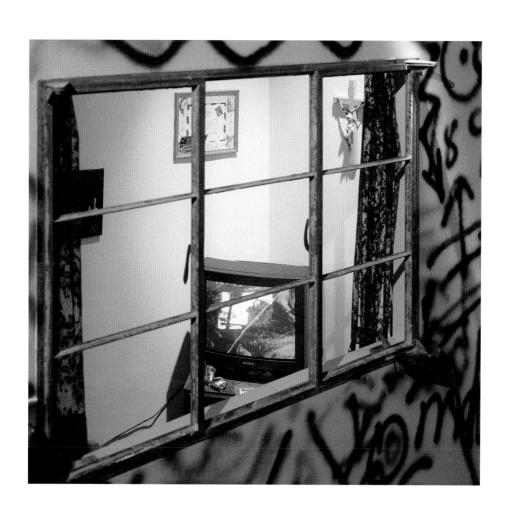

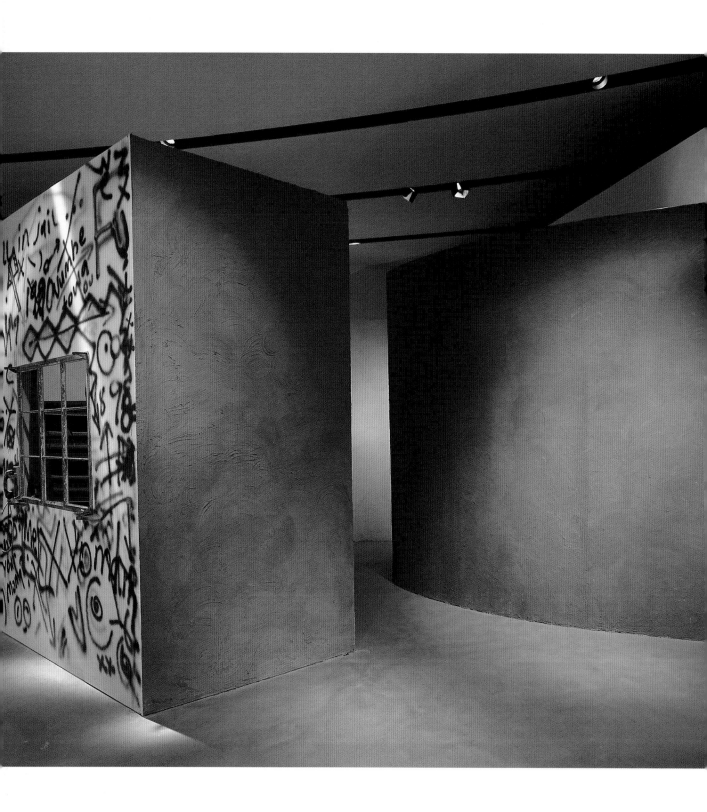

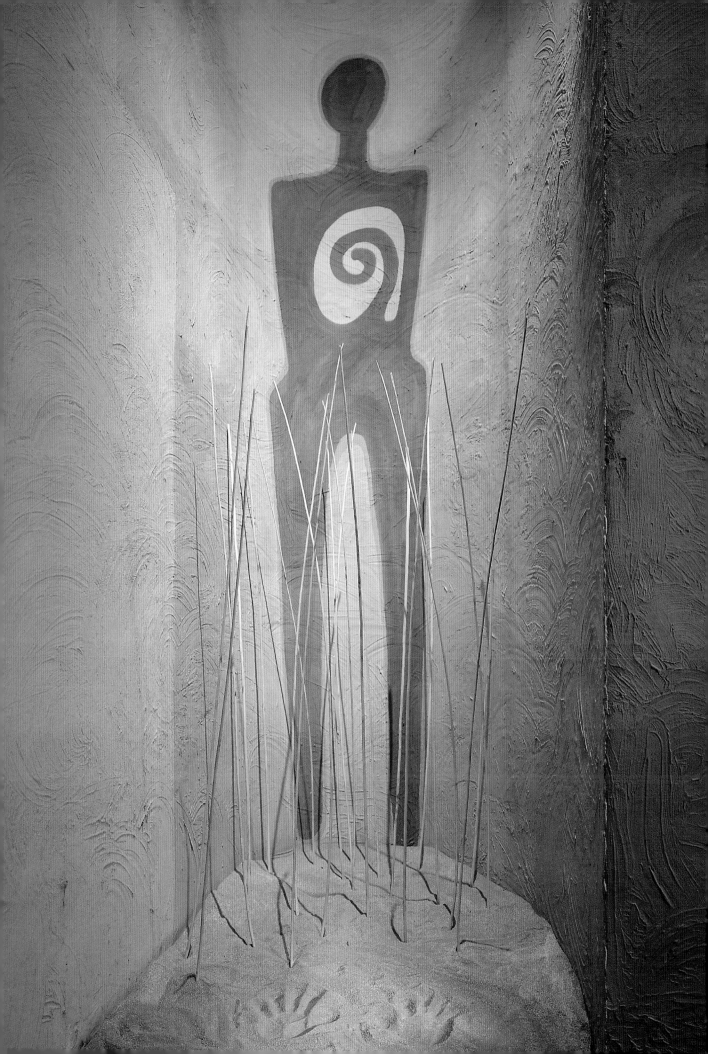

MARIANNE NICOLSON
HOUSE OF ORIGIN

KINGCOME INLET (GWÁYI), THE PRESENT-DAY COMMUNITY. MARIANNE NICOLSON

MARIANNE NICOLSON: HOUSE OF ORIGIN

MAINTAINING IDENTITY IN THE MODERN WORLD
GERALD McMASTER

"Hutlilala, du<u>k</u>w<u>a</u>lala, <u>k</u>'otl<u>a</u>la; To listen, to look, to know." This inscription, which appears on the Copper Doorway painting, ensures that the newcomer will respect the old ways, and they too will come to understand the power of belonging. Elders are often heard saying, "It's hard to be an Indian," with the implication that observing the strict ways of being is not an unhurried process; rather, it is a lifetime commitment. Yet their practice does not seem to be overwhelmingly influential, especially when there are so many attractions to seduce us. Preparing young people is an arduous task when, all around them, distractions from high-tech to powwows call out.

Marianne Nicolson lives in the small and isolated Kwakw<u>a</u>ka'wakw community of Kingcome Inlet, British Columbia. She moved here, to her mother's community, in the early 1990s, having grown up in Vancouver and Victoria. After studies at the Emily Carr College of Art and Design in Vancouver, she completed an MFA at the University of Victoria. In addition to her academic training, while living at Kingcome she managed to immerse herself in the traditional Kwakw<u>a</u>ka'wakw culture that has greatly influenced her work. She learned the traditional customs of singing and dancing as well as the tribal beliefs. Of *House of Origin*, she told me, "I've drawn from traditional forms and incorporated contemporary styles with them. They express ideas about community, about the individual within a community, and how one relates."

Among the Kwakw<u>a</u>ka'wakw, the people from Kingcome Inlet are referred to as the Dzawad<u>a</u>'enu<u>x</u>w. It is a one-hour trip by air from Campbell River, or eight hours by boat from Alert Bay. The only road, which winds its way through the village, is the one used by the community's sanitation department. The people here are at ease on both land and sea. In historic times, other villages were accessible only by boat. All houses faced the water. As late as the turn of the century, the houses were still arranged in the traditional formation of closeness, although undergoing some stylistic transformation. It is highly possible that the roadway that passes in front is the same we now see. Today, however, the houses are far apart, typical of many contemporary reserves, unlike the "village" quality of historic times.

The most inspiring presence in any West Coast community is the *gukwdzi* or "big house." Located in the centre of the community, the *gukwdzi* is where all gather to celebrate important community functions. Large enough to accommodate both local

people and visitors, it is a long, simple structure: four great
central posts hold up two giant beams along with six side
posts. For Nicolson and her people, the *gukwdzi* is the "house
of origin." Like many of her people before her, she receives
inspiration from its centre. In her previous work she uses the
structure to remind us of the strong relationship the commu-
nity has with the land and sea and its relative isolation from
other regional communities. The idea of the *gukwdzi* becomes
a metaphor for the community itself and the identity associated
with it, the house providing a firm foundation for communal
identity.

Nicolson, however, recognizes that the people of Kingcome have accepted many
changes in their architecture over the past century, from large multi-family dwellings,
to late nineteenth-century European vernacular housing, to the modern government-
issue homes found on most reserves across the country today. This style of housing
reflects the government's efforts to homogenize all aboriginal people. In addition, the
houses at each stage become progressively smaller and set farther apart. Yet the
gukwdzi at Kingcome retains its symbolic presence within a rapidly changing commu-
nity. The *gukwdzi* is what remains to remind the people of their identity, of where they
came from, which is the land and the houses where they were born. This "house of
origin," which speaks of the importance of retaining community structure and family
identity, sustains Kwakwaka'wakw identity. The church, band office, store, school,
soccer field, and post office are important facets of this contemporary community.
Large satellite dishes ensure that the community is wired to the global community,
invalidating any criticism that they are isolated. Relative isolation, however, has long
been advantageous for aboriginal communities because it enabled them to carry on
their daily expressions of language and ceremony away from the watchful eyes of sus-
picious government officials.

In Nicolson's installation, *House of Origin*, two paintings stand opposite each
other, one at each end of the house. On the outside of each painting are texts written in
Kwakwaka'wakw, while the inner sides are paintings that depict the story itself. The
blue painting translates:

> The great Flood had not yet arrived when Kawadilikala and his
> younger brother Kwa'lili dressed in their wolf cloaks travelled to
> look for new land. Kawadilikala came to Gwáyi [Kingcome]. Kwa'lili
> went to At At ku [Wakeman]. Kawadilikala said to his younger
> brother, "Let us take off our wolf cloaks, and we will be just men."

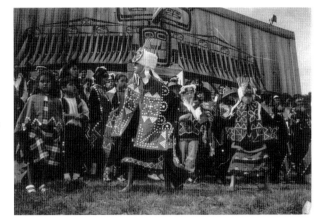

The red painting translates:

> What does this bird sound like
> in your land?" asked Kwa'lili. "Dza'wala," replied Kawadilikala.
> Then the name of your people will be the Dzawada'enuxa," said
> Kwa'lili. "What does the bird sound like in your land?" asked
> Kawadilikala of his younger brother. "Haxwala," said Kwa'lili.
> "Then the name of your people shall be the Haxwamis." So it is.

Without these translations, the texts are inaccessible. Why has Nicolson decided that we should enjoy only the calligraphic quality of this unusual orthography? There is a sense of urgency in the way she applies the text, yet it remains secretive. I would argue that what is being suggested here is not so much the texts' indecipherability (since she has provided translations), but the reality that most aboriginal people cannot read, write, and speak their aboriginal languages. We are often quoted dire statistics that many aboriginal languages are endangered, that only a handful of the total of fifty-three languages will survive. Indeed, with many aboriginal children seeing, hearing, and speaking one or both of Canada's "official" languages, these predictions become ever more possible. What is so important about maintaining aboriginal languages? For one thing, they are an important means of communication and a way of articulating the culture. Aboriginal languages bring objects alive, investing them with meaning. For many, trying to make sense of objects displayed in museums is like trying to find the proverbial key to unlock the secrets or the codes to knowledge and understanding; otherwise the objects remain inert and will sit on shelves forever. Aboriginal languages also maintain unity. Ceremonials, potlatches, and other festivities become the adhesives that hold communities together, and together they celebrate life. Original language upholds Kwakwaka'wakw identity, or more specifically Dzawada'enuxw identity. The language is fairly useless outside Kwakwaka'wakw communities, however, where it is more symbolic and cultural and is used for ceremonial rather than everyday purposes. Thus the language as it is written in the paintings signifies its inaccessibility, but at whose expense?

A photographer by training, Nicolson combines the paintings with suspended text and photographs that frame the outer walls of the house. The photographs depict the people and the local landscape, both indicative of Kwakwaka'wakw identity. In the works that are bounded by the walls, the references are to familial relations — 'nula (older brother/sister), gagamp (grandmother/grandfather), wak'wa (brother, sister, first

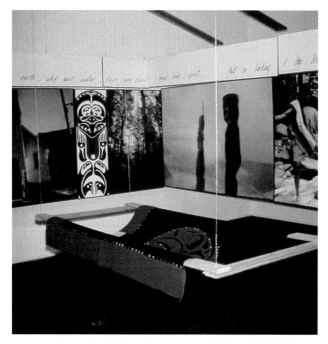

cousin), *tsa'ya* (younger brother, sister), *namwut* (a relative), and *hi'lu's* (great-grandparents). Around the outer structure are photographs of the community and the imposing landscape around Kingcome. The words *nage* (mountain), *t'tama'is* (beach), *'yugwa* (rain), *t'tisala* (sun), *K'waxi* (tree), *wa* (river) describe the structure of the cosmological landscape. Photographs of smiling children, ceremonies, and the everyday life of Kingcome show how important family is to community and what it means to be Kwakwaka'wakw.

The words, "Having consumed you I cast you back into the world changed from what you were," appear in the bear and frog painting. Our entrance/exchange/departure from the *House of Origin* is a form of consumption; it is experiential. As in traditional Kwakwaka'wakw culture, we leave these *living* structures having experienced something profoundly moving that will affect some aspect of our lives forever.

MARIANNE NICOLSON SPEAKS . . .

On her community: I'm from a small community called Kingcome Inlet, which is on the west coast of British Columbia. Its traditional name is Gwáyi. It has a history that extends back to our origin story, which allocated this land to the Dzawada̱'enux̱w people, the descendants of Ḵawadilikala. We've remained on this land from the time our people first came into being. That gives the people a certain sense of identity, which is different from that of other people who have been removed from contact with the land.

Kingcome retained a lot of its traditional culture because of isolation. There are no roads. You can get here only by plane or boat. Even today, the traditional culture is very visible. We have a big house that is about a hundred years old. We have old poles that have been here since the turn of the century. It's not that I feel living in Kingcome is better, but there is an opportunity here to experience something that is now rare. There are very few who retain indigenous ways of life, thinking, and values. Our community still has a thread that connects us with our ancient past. But there is a fear of being swallowed up, of disappearing into the giant mass, as many of our people have done.

On identity: My identity has shifted. At times I have felt more attracted to non-Native culture and ways. Over the last five years I have been much more part of my mother's side — she is from Kingcome Inlet. It is a struggle that I play out in my art work. I find being bicultural is a common issue, not just for me, but for us as a community. My art is my attempt to deal with it.

On her role as an artist in the community: After living in Kingcome Inlet, my perception of what an artist does has changed. I collaborate with community in my work because it stems from communal experiences and close individual experiences. Fundamentally, experiences come down through the individual, through me. All the community experience still gets funnelled through me as an artist. Before coming here to live, I considered it my role to produce art work. What I discovered is interaction with the community, and projects such as building a canoe are equal to producing a painting. I have also co-ordinated an elders' gathering, which was just as much an artistic production as creating art work. If I were living in the city, my role as an artist would be to paint, draw, and produce works. Now my role has expanded.

LEFT: KINGCOME INLET (GWÁYI). MARIANNE NICOLSON

BELOW: WELCOME POLE AT KINGCOME FLATS, 1933. F.J. BARROW, ROYAL BRITISH COLUMBIA MUSEUM (PN 2422)

On community: The question of community constantly pops up in my art work because here it is lived day to day. I think we have an idea of what community was. I think we have an idea of what we would like community to be. But we are not sure what community means to us here and now. The idea of family is still very strong. Your community is your family, your strong base. We have to understand that we are from one family. But in the last thirty to forty years conflicts have come into play and the idea of community has become fragmented.

On identity and community: Community has had an incredible impact on my own self-identity. When I was in the city, I could play with my identity. I could be one person one day in one context and another completely different person in another. But here I can't say, "This is who I'm going to be." I am defined by my family, by my standing, by my rank, and by my nation. At times it can be restricting, but it can also be tremendously stabilizing. I am Dzawada'enux̱w. I am born into a Potlatch family. I have a Potlatch name. I know who my mother and my uncles are because they all define who I am. It is how I relate to other people and community members. I know exactly what they will do with me when I die. I know what songs they will sing, how they will bring me to my gravesite. They will howl like wolves four times. In my work, I try to express this double-sidedness: the secure feeling of knowing who I am through my heritage, yet still having the desire to explore and expand as an individual beyond community expectations.

On living and working in two traditions: I don't feel I can produce only traditional work in a traditional context. For example, I did a dance screen for a potlatch, which will be viewed by everyone who attends. It is a completely traditional context with the local community audience, not like a gallery setting. But I want to be true to my experiences as having grown up both with Native and non-Native influences, so I've created works that deal with this fusion. My work has evolved as a combination of all these elements. My experience of being biracial, of living on the reserve, is what I try to express through my art work. One of the reasons I'm incorporating Northwest Coast

design with Western imagery is because I'm painting from my experience. There's nothing wrong with accepting other influences — we could learn to work with those influences and move forward, accept where we are and build new things.

On accepting the "new": Blankets weren't used five hundred years ago. They were something that the traders brought. Our people took them and created something entirely new, and that was completely acceptable. Now, when you create something totally different, people aren't sure how to take it. I'd like our people to get back to where we can look at new materials and ideas and incorporate them into our own identity.

On her installation: In *House of Origin* I've combined photography and painting. Two painted panels form the ends of a house, and twelve photographic Plexiglas panels form the sides. In the paintings, I've used traditional forms and incorporated contemporary styles. They express ideas about community, about the individual within a community, and how one relates. The big house is predominant in all my work. It represents the idea of self. The house is a symbol of that development, of seeking self. It's a strong symbol of identity, home, family, and community. I constructed a house to be viewed from all sides, from both the outside and the inside. I wanted to express ideas about perspective and how people view other people's lives. In a large part, our lives have been highly documented because others have imposed their perspectives. I want to present this work so that there are multiple viewpoints. I wish people to have a viewpoint of my home and experience. I also want to represent it in my own way and not necessarily have everything understood.

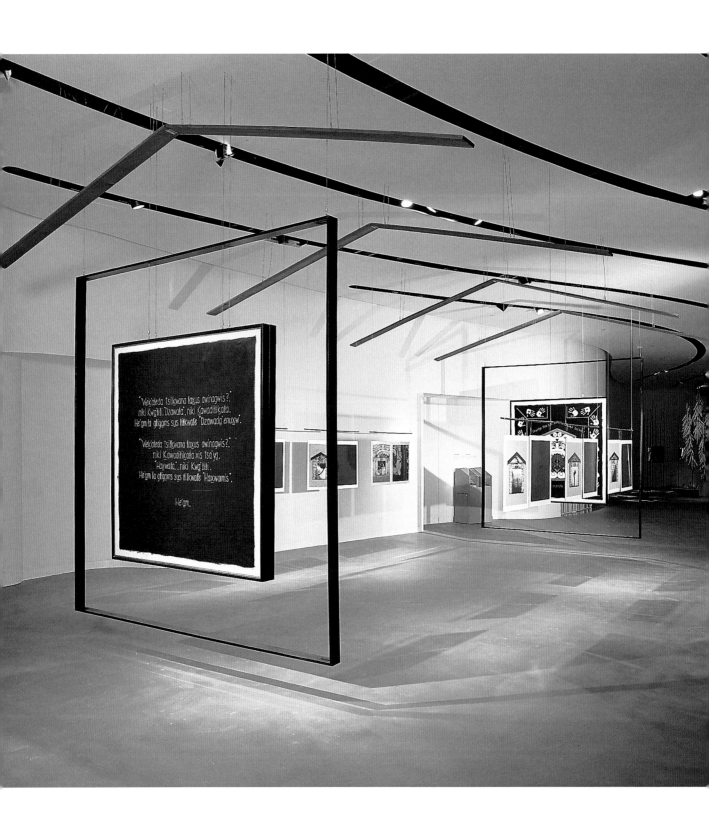

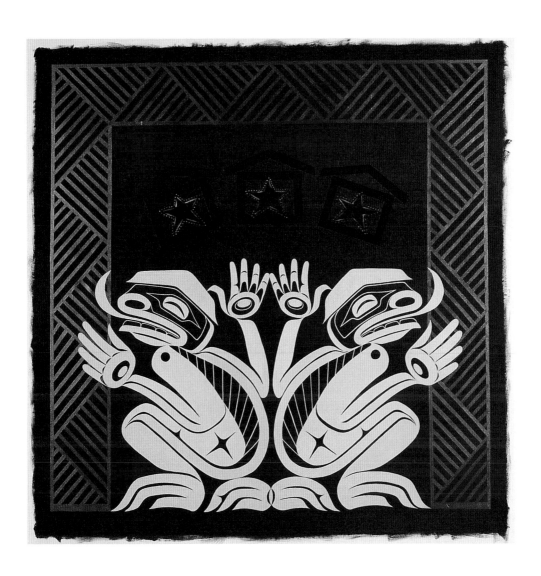

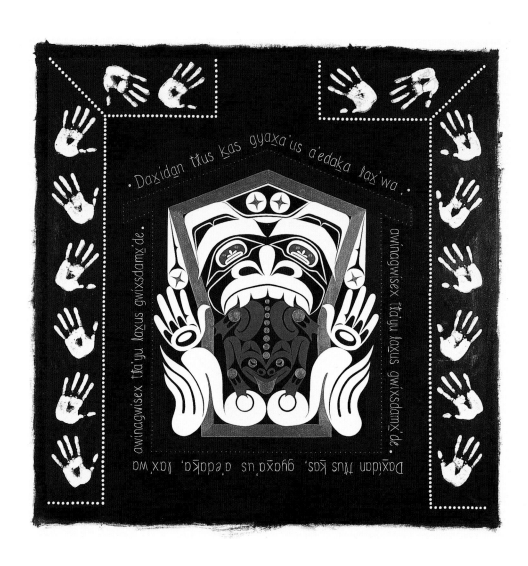

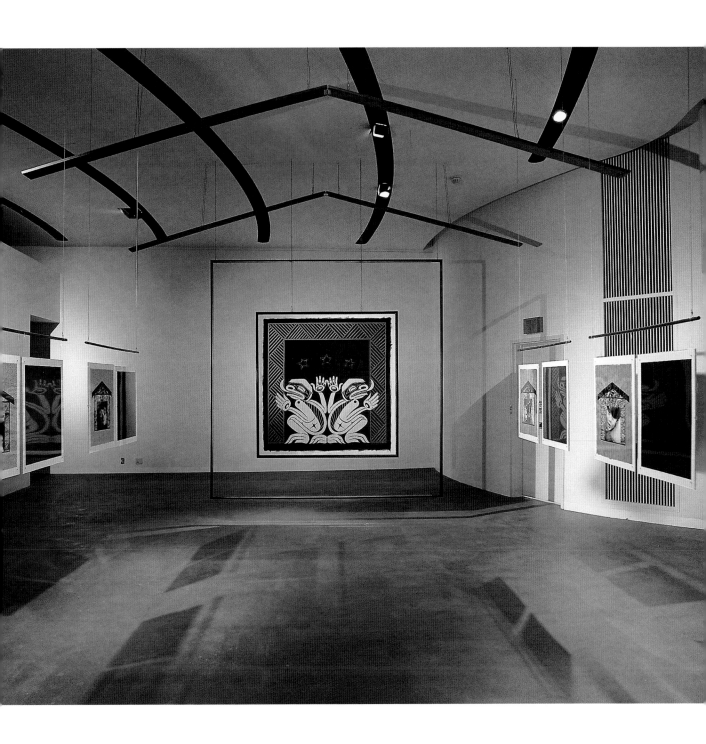

SHELLEY NIRO
HONEY MOCCASIN

MOHAWKS IN BEEHIVES, 1991. SHELLEY NIRO

SHELLEY NIRO: HONEY MOCCASIN

HOME ALONE
PAUL CHAAT SMITH

The independent feature film, written, directed, and starring Indians, has been something of a Holy Grail for Indian filmmakers for the last decade. When asked how she came to believe she could accomplish this immense, nearly impossible task, Shelley Niro talks about her childhood on the Six Nations Reserve. She and her sisters and brothers were often alone and became proficient at finding ways to amuse themselves.

Television and radio offered limited choices (it was the 1950s and early 1960s), school was part of the problem rather than the solution, and Niro learned at an early age that the world's ability to provide amusement and engaging entertainment was limited, at least in southern Ontario. She and her siblings became fighters in a very personal war against boredom. Winning required invention and creativity, and the competition was often fierce. Storytelling, poems, drawings, plays and songs written and performed, installations (though not called that at the time) — all were created, critiqued, and trashed. The rivalry was intense, and among these judges, no one was easily amused. Niro's childhood and her struggle against monotony became a perfect training ground for the life of an artist.

The land and people of southern Ontario and upper New York state, or to put it another way, the traditional homelands of the Mohawk people, are the canvas that Shelley Niro uses for her provocative investigations. Her art has been fashioned from a broad range of materials, including paint, sculpture, installations, photography, video, and, most recently, film. Her contribution to *Reservation X* is *Honey Moccasin*, a feature film complete with bona fide movie stars Tantoo Cardinal and Billy Merasty.

Although widely travelled, Niro was born in Niagara Falls, and she has lived almost entirely on the Six Nations Reserve or in the nearby town of Brantford. The land is rich in physical beauty and historical importance. Six Nations is one of the largest Iroquois Reserves and home to many key political and cultural figures. Brantford is named for Joseph Brant, a Mohawk diplomat and military leader, who founded the town during the last century. Amused to live in a town named after the famous Mohawk, Niro's work is infused with a particularly Iroquoian sensibility that works almost like an inside joke. The joke is this: the People of the Longhouse (Haudenosaunee) were, not so long ago, a vast and powerful nation that routinely changed history and rewrote maps. They were feared and courted by Indians and Europeans and by the upstart nations of Canada and the United States. This was a fact only three or four lifetimes ago, yet even

in the heart of the heart of Six Nations it doesn't appear to count for very much. Niro's most compelling work has used Brantford as its backdrop, showing how, even in this place named after an Indian leader whose statue graces the main square, the Indians who walk the streets never seem to quite fit in.

Mohawks in Beehives features Niro's sisters vamping before the camera in loud clothes and louder makeup. Her most celebrated and most requested series, it is not only funny and revealing but is also the best example of her method in action. The piece came out of a reaction to weeks of news reports on the Gulf War in the dismal winter of 1991. The country was still trying to come to terms with the Oka rebellion of the previous summer. If history was being made, its effect was to make Niro feel like a powerless bystander. "It was almost like your personal existence has no meaning at all," she said, and she organized her sisters to symbolically reclaim Joseph Brant's town, not with banners and rifles but with obsolete hairstyles, attitude, and costume jewellery, the bigger the better. Many artists created work in response to Oka and the Gulf War, but none looked like this. *Mohawks in Beehives* is about taking things back, taking control, and seizing power by refusing victim status. The images of strong, confident Native women in Brantford, walking the streets and posing before statues on their terms, neither victim nor symbol, found great resonance with a wide audience.

Niro's is among the most accessible of contemporary Indian artists' works. Another well-known piece, *The Iroquois Is a Matriarchal Society*, featuring her mother underneath a hairdryer, is an example of why this is so. The artist's witty use of her mother as subject refers to the strong role women play in Iroquoian culture. Yet she can't help question: Are these powerful women being co-opted so easily by Western culture, as symbolized in the equally powerful vacuum of the hairdryer? It's a funny piece, but Niro's jokes are never one-dimensional. She has managed to create work of multilayered meaning and depth that has avoided the traps of heavy-handed irony, propaganda, and idealizing a romanticized past.

At the end of her first film, fireworks explode over Niagara Falls against a night sky and the clock strikes midnight. It is 1 January 1993 and the first seconds of the

Honey Moccasin (still), 1997. Florene Belmore plays Mabel, the daughter of Honey Moccasin. A performance artist, Mabel uses her mother's bar, the Smokin' Moccasin, for her presentations. jeffrey thomas

next five hundred years. *It Starts with a Whisper* is filled with vision quests, pleas for understanding and justice, spiritual enlightenment, elegies for Indian tribes who did not survive the last few centuries, and even a cameo from Elijah Harper, appearing in a feathered headdress among the clouds. It is without a doubt the most serious Indian comedy ever made.

In the film, a young Indian woman named Shanna makes a journey from the banks of the Grand River to Niagara Falls on the last day of December, 1992. Shanna speaks to unseen ancestors dressed in traditional clothes, and later in the car trip south her sisters alternately ignore and ridicule her. (One sister has won a radio contest for a free weekend at Niagara Falls.) The sadly beautiful fireworks over the Falls, against a tacky backdrop of bingo palaces and souvenir gift shops, set the stage for a resolution of Shanna's questions. Elijah Harper appears in a dream sequence, offering encouragement and hope. It is moving and humorous at the same time. Niro's characters end their journey (and begin ours into the next half-millennium) with elaborately choreographed musical numbers that somehow manage to strike the perfect chord. She captures the tough love, humour, absurdity, and honest confusion of being red and alive in the 1990s.

Her work for *Reservation X* is also her most recent film. *Honey Moccasin* imagines a contemporary reserve where someone has stolen every dance outfit, feather, shawl, and piece of decorative beadwork in the entire community. As part of the film narrative, they were used in place of the authentic costumes that were stolen. Who would do this, and why? And how would people respond to such a theft? In Niro's world, they are challenged to find new ways to define what it means to be Indian, and they respond with daring and imagination and creativity. The outfits in the installation are made from found objects and display Niro's humour. At a time when pan-Indian pop has become a tidal wave and Indian identity seems like a question many of us answer with skilful accessorizing, *Honey Moccasin* suggests that being Indian takes more than feathers and beads.

SHELLEY NIRO SPEAKS . . .

On community: My community is split into two groups: one is my family and the other is the artist community. I rely on my family for support in regard to acceptance, reflection, nurturing. Here I can relax and more or less be myself. The physical overrides the intellectual, spiritual growth is encouraged, and the day-to-day realities are always present.

The artist community also nurtures, but it also mystifies and challenges. One treads these fields with no safety net. Both these communities remain small. I believe you have to participate to belong to a community. I question how I fit into either of these, as I feel I do not fully participate in either one. As an artist, my contribution is the work I produce. The city of Brantford is away from any major art centre, and therefore I am marginalized. The reserve I come from is about a fifteen-minute drive from my home. Again I am marginalized, as I am now an *urban* Native.

At this point in my life, I want to contribute in a positive way. This is through art-making and an ongoing dialogue through my work.

On identity: To an extent you are defined by your community. This can be used as a cop-out — blaming others around you, never taking full responsibility for your own actions. Having said that, the environment does have an enormous effect on personal outlook, problem solving, and how stimulation gets interpreted. Does one ever really grow up?

On living on the reserve: It filters through me all the time: Would I really want to live on the reserve again? That notion is romanticized to a point where one thinks, Yes, wouldn't it be great? However, I feel there is no security or any real autonomy in this thinking. Indians should be able to live anywhere and not have any stigma about where they choose to live. It comes down to basic economic development. One leaves the reserve to find independence through one's own ability to become self-supporting. And once this independence becomes realized, it is hard to revert back to a situation where one is not as independent. I also think we should look at the whole of North America as ours and not feel like we have to huddle into a corner and fight over these small territories.

TUTELA HEIGHTS, GRAND RIVER, ONTARIO. DEBRA DOXTATER

On identities: My work gets created through cultural identity. I don't start off saying, I'm going to make something with an Iroquois look to it. But those elements impose themselves on my work. In the end it has an enormous impact, and my own identity seeps with this cultural construct. In the beginning, I was very aware of my role as an artist, creating work that would reflect a feminine cultural identity. In the past, I wanted to create opposing views of how Indian women were seen. By playing with what was already there, I could deconstruct and invent new personalities. In the end, I came back to what is culturally embedded. I present images that speak loudly of Indian women who happen to be Iroquois.

On inspiration: Who knows where inspiration comes from? I can smugly suggest it comes from being an Iroquois, a Mohawk from Six Nations, deeply drawn to the history of Joe Brant and all of his descendants from the Mohawk Valley in New York state. I can suggest it comes from being a woman living in this particular time, wearing this particular skin. I can make outrageous statements protesting the human condition, criticizing humanity, bad manners, and behaviour. But how do I explain nights of sleeplessness, haunted by the resolution of unfinished work, searching within my mind for the perfect kind of frame for compositions, tripping over the text that will accompany the images so as to not confuse and at the same time confuse the viewer towards further speculation? And when all of my work is finished and no project sits waiting for me to return to, and I am almost without stress or chaos, I come back to a familiar place of flipping through my ideas of what I want to do next.

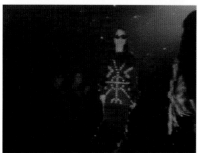

On her film: *Honey Moccasin* is the name of the film and the name of the main character. She owns a bar called Smokin' Moccasin. This place becomes an extension of everyone's living room. Honey tells stories, sings songs, and allows her stage to be used for entertainment and enlightenment. Her daughter Mabel is a performance artist who uses the space for her presentations. They are a little strange, but the audience likes them. One of the main themes of the film is that someone is stealing the powwow outfits from the homes of dancers. Eventually we learn who is doing all of the bad deeds. We hear about this and other events from the television set, where everyone gets their information. Richard Rock (played by Paul Chaat Smith) is the new commentator. He relays history and advice. Bernelda Birch is the TV journalist. She is also in Honey's band, the Mock-A-Sins. Zachary John owns a rival bar across the street. He competes with a karaoke set-up, thinking he is keeping in step with modern times. His earnestness towards the community is demonstrated through acts of entrepreneurship, for example offering vegetarian meals in his restaurant, The Inukshuk Café, to a diabetes-laden people. Zachary's father, Johnny John, creates a conflict between himself and his son. The quiet but resilient Beau also acts as a catalyst between Honey and Zachary.

On the film's collaborators: *Honey Moccasin* had many collaborators. The fashion show sequence was made possible through the efforts of a class of students I instructed at the University of Western Ontario in London. They participated in the construction of sets, costumes, wardrobe. They also worked on the set by acting as crew for the day. Their involvement made the working environment experiential and energetic. The musicians who wrote the film music also contributed in a deep and meaningful way. Their original compositions bring a new life to the text and visuals. Willie Dunn, Jani Lauzon, Zdenek Konicek, and Richard Lawler give *Honey Moccasin* its own voice. Daniel David Moses allowed

me to use his poem "Inukshuk." These promi-
nent people have permitted me to use their
talents. I have taken the responsibility quite
seriously.

On the film's perspective: The target audience for *Honey
Moccasin* is First Nations, Natives, and Indians. I want them
to relate to the situations in this film without trying to find a
way in. They're in as soon as the film starts. Most of the
characters are Indians. There is only one non-Native character,
who makes a brief appearance. Conflicts and their resolutions
come from the Native community. The entertainment, the
social commentaries, the acts of wackiness all come from this fictional reserve. We are
seeing variety, strength, weakness, emotion, and humour in this film.

On humour in film: Daniel David Moses once told me that romantic comedy
resolves itself by ending in a love story. In this case it is between a man and his
community. The use of humour makes the listener sit a little closer to what is being
said and wait for the bite.

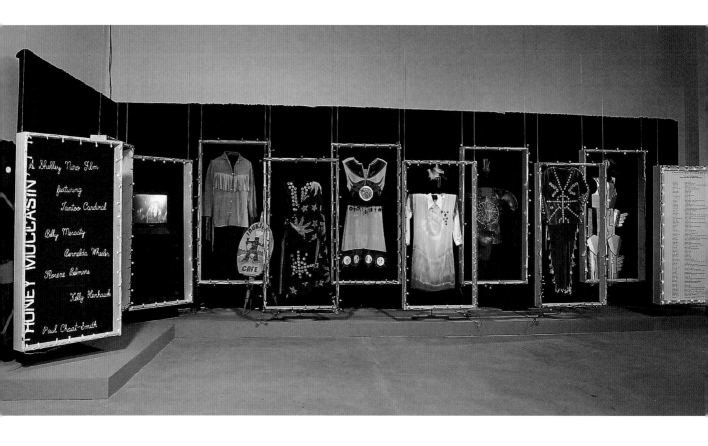

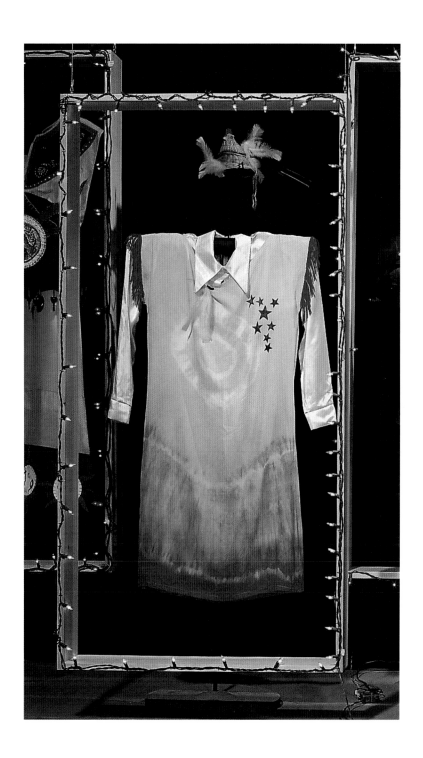

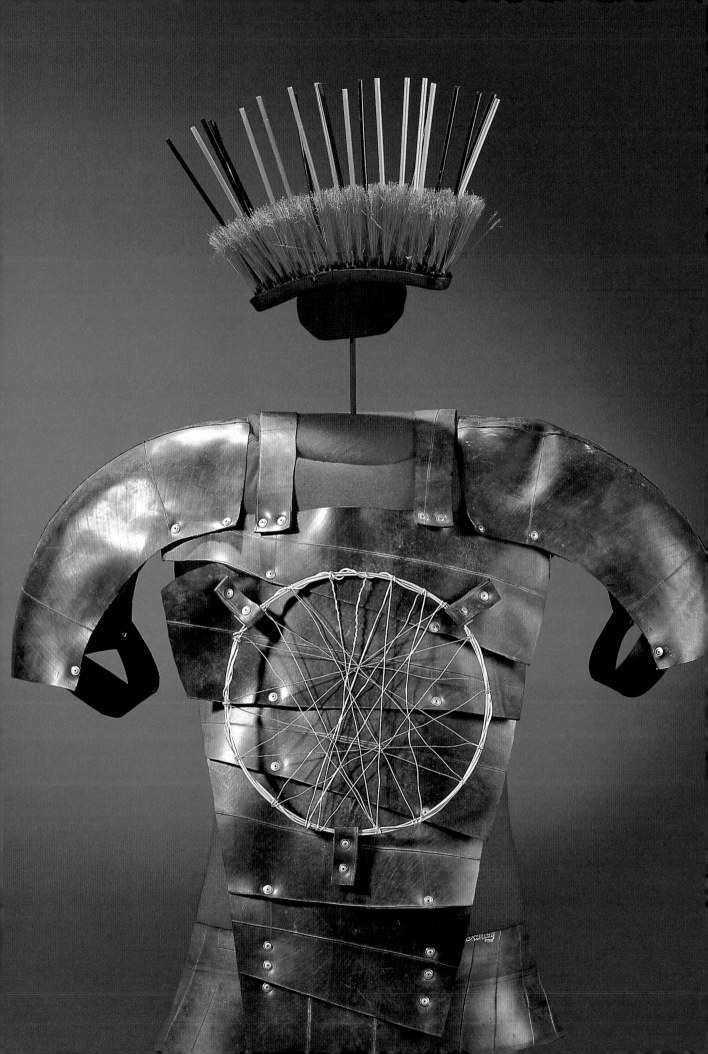

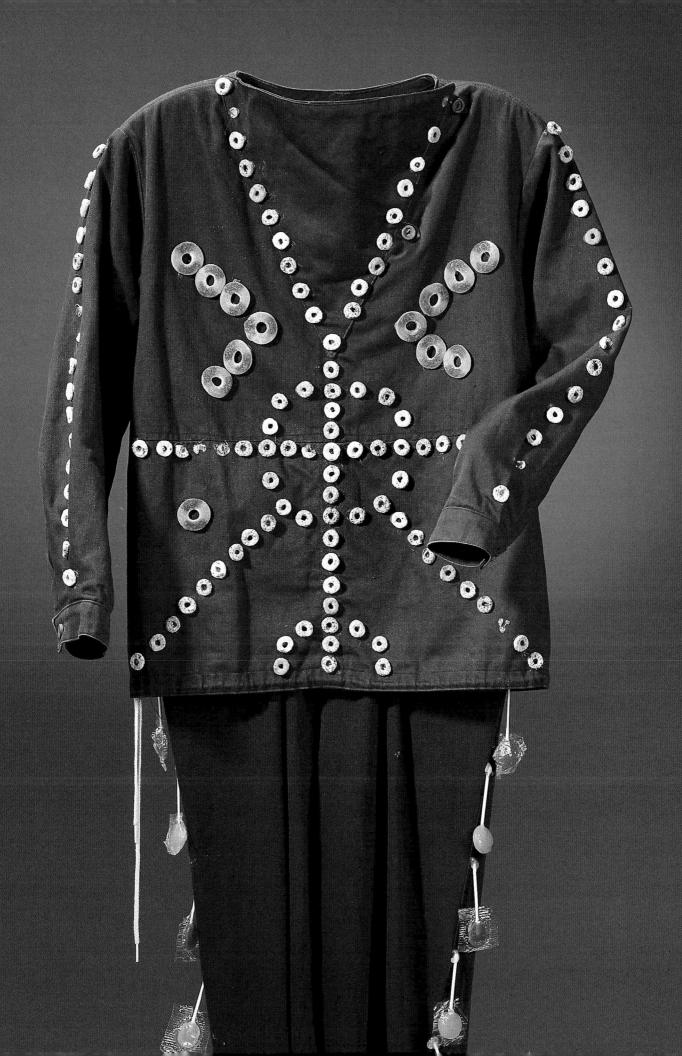

JOLENE RICKARD
CORN BLUE ROOM

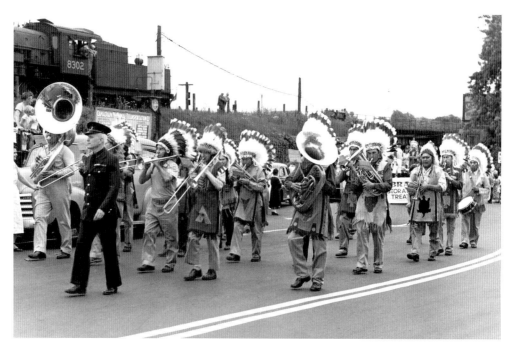

ONEIDA MARCHING BAND. COURTESY OF JOLENE RICKARD

JOLENE RICKARD: CORN BLUE ROOM

UNPLUGGING THE HOLOGRAM
PAUL CHAAT SMITH

Jolene Rickard's work is about power, theory, and corn, yet it doesn't look like anyone else's work about power, theory, and corn. Why is this?

Although taken a decade before she arrived on the planet, a black-and-white image from the 1940s provides important clues. The photographer has captured a dozen men who call themselves the Oneida Marching Band. They are playing trombones and French horns, tubas and trumpets, and are wearing Indian costumes, including full Plains headdresses. (The fringed leather jackets are to die for.) Most have moccasins, a few, possibly the more practical ones, are in street shoes. They are marching on a bridge above Niagara Falls, walking from Canada to the United States, or possibly from the United States to Canada. A thousand or so of their brothers and sisters are marching with them.

God only knows what song they are playing.

The Oneida Marching Band seems to be having a pretty good time, and why not? In a few hours, after concluding the festive — yet militant — affirmation of treaty rights guaranteeing free passage across the border, they'll be sitting down to a banquet at the best hotel in one of the premier resorts in North America.

The Border Crossing Celebration was the invention of Jolene Rickard's grandfather, Clinton Rickard. He founded the Indian Defense League of America in 1926, and he fought tirelessly for Indian people. Caring more about political effectiveness than how it might look to the gatekeepers of movement aesthetics, Clinton Rickard used imaginative methods, up to and including brass instruments, to keep the US and Canadian governments from extinguishing Indian treaty rights. He knew that hard-won victories must be constantly defended, and he came up with the idea of the Border Crossing as a way for Indian people to safeguard their rights in a concrete and personal way. It was a fine day with wholesome activities for all, featuring softball games, baby contests, floats, political speeches (even white politicians asked to be on the program), and a flashy dinner dance that made the society pages of the Buffalo papers. You could almost miss the fact that seemingly every Indian within two hundred miles had taken part in a demonstration that put the American and Canadian nations on notice that it probably would not be a good idea for them to wake up one day and decide Indian treaty rights were no longer valid.

It was an ingenious and successful tactic that continues every year on the same third Saturday in July. That mix of theory, of challenging and asserting power, and of the insistence on actually walking across the border (trombones and headdresses optional) informs the way Clinton Rickard's grand- daughter engages the world and creates art.

Jolene Rickard is currently an assistant professor of art and art history at the University of Buffalo. She also is politically active both on the Tuscarora Reservation where she lives and in the Iroquois Confederacy. She pursues her theoretical and critical work with the same energy as she pursues her art. For Rickard, they are all connected and all essential.

During the 1980s, Rickard built a successful career in advertising and television production. Her parents had always been understanding, even supportive, about the art college in London and her life in Manhattan — up to a point. Then one day they phoned her up and said that it wasn't enough to talk about traditions and corn and beadwork. She would have to learn how to do all of the these things, and the only way she could do that was to come home. She returned to Tuscarora in 1989.

Like her grandfather, who used his Masonic and war veteran connections to build support in his battles with the United States and Canada, Rickard is always looking for the piece of information, insight, or direction that can make the difference, no matter its source. Unlike so many others, she does not believe that excellence and being Indian are mutually exclusive. Her scholarship, be it on Iroquois beadwork or post-modernism, has earned her a national reputation as well as a PhD. Her influential critical essays have argued that the art world's current interest in Indian art is a trap that reduces Indian cultural expression to victimhood, protest, and craft. She thinks many Indian artists are all too willing to submerge their work into a system that can never take seriously the idea of an indigenous knowledge base. She also challenges the idea that indigenous expression can ever be divorced from a direct connection with the land.

There is a technical precision in Rickard's art that echoes the political leadership of her community at its best: careful and deliberative and exacting. Shortcuts are un-known here. Knowing how to grow corn is important, but it isn't enough. Loving your community and a willingness to fight on its behalf are important, but fighting power without a careful assessment, without theory, will lead only to a noble defeat.

She writes, "Most Indian people are descendants of one survival strategy or another."

For some that brings to mind fuzzy memories of heroic (or perhaps merely lucky) great-grandparents, or a famous leader from another century. For Jolene Rickard, it's not so far away and not so abstract. In 1958, the Power Authority announced plans to flood the Tuscarora Reservation by constructing a new reservoir. The organization was led by Robert Moses, who was one of the most powerful men in the United States. The Power Authority had destroyed far wealthier and more influential communities all over the state, so it anticipated few problems in buying off and relocating some Indians. But their research was flawed; they didn't know about the trombones. The brilliant campaign that resulted in one of the Power Authority's few defeats has become legend in the annals of Indian resistance. In the end, it took everything to stop the bulldozers, including placing women and children directly in front of them. In a movie script, the Indians would defeat Moses and keep their reservation. In real life, however, the spectacular victory meant the loss of much of the reservation: the new reservoir still flooded nearly half of it. Rickard's work is grounded in that history and forged from hard lessons on the cost of political struggle, the price of victory, and the true meaning of words like tradition, honour, and resistance. Her complex installation *Corn Blue Room*, which includes photographs of corn and dams, forms the shape of an Iroquoian longhouse. At its centre, corn is suspended, while a CD-ROM narrative can be manipulated to take the viewer deeper into the story. The idea is to imagine a small Tuscarora community, surrounded by powerful dams and electrical generating stations, and its fight for cultural survival.

The reservoir hasn't gone anywhere since 1958, either. It is a constant reminder of tragic loss that usually overwhelms the sweet memory of defying impossible odds. On top of everything else, it's also in the way. Jolene Rickard must drive around the hated reservoir each day she goes to work in Buffalo.

It makes her late, and she has no time to be late.

JOLENE RICKARD SPEAKS . . .

On her people: My people, the Tuscarora, were forced to migrate north for survival after the Tuscarora Wars in 1711-1713. It was a long migration. We were welcomed by the Oneida people. We came in through the adopting nation, the Cayuga. We reside under the wing of our elder brother the Seneca, particularly Tonawanda Seneca. For that we are grateful. It was the women who brought my nation forward to this point. I think about the choices they had to make of keeping my people together when there was so much opportunity for us to dissipate.

On the importance of Niagara Falls: It was the crossroads for many lives as an economic opportunity. In the 1800s the Falls was acknowledged as one of the most popular tourist sites in the world. It was one of the "frontiers" somebody could go to, experience the force of nature, and get a glimpse of the "Indian." The Indians they saw were Tuscarora women. They were getting a look at the women because of our role in the Revolutionary War and our sympathy toward the emerging American colonies, as well as for our helping the Porter family, who had purchased that land. The Porters made an agreement with the Tuscarora, who now had the right to sell their wares at the rim of the Falls. The beadwork we developed had a kind of synthesis of our cultural ideas and also appealed to the Victorian eye. At the same time, it created a woman's economy, of which they were in charge. It kept families together and helped my people in transition from a dependence on agriculture to working in industry. Today, the beadwork scene is a source of cultural continuity and pride. We would not have been able to do that if we didn't have the location at the rim of this great wonder.

On contemporary activism: Some writers have said that the Pueblo revolts, the first resistance in Indian America to the taking of land, acted like a catalyst for Native peoples to wake up and say, "It is not done yet. We still have to stand up and fight for our homelands." As for young Indians who come into my class, it is almost like they do not understand. Or somehow we have not done our jobs in helping them understand what their journey is going to be. They are taking the ability to be a diplomat and an activist very lightly. It is what all of us have to do in whatever way we express it. I just happen to express it visually through my work and in my writing. I am trying to expand it in a way that is meaningful to our communities. It is a passion. I feel lucky that I

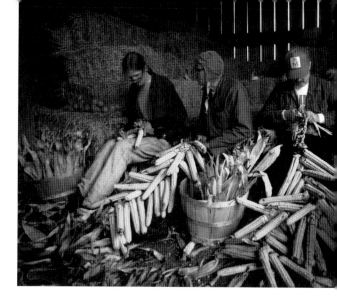

CRACKED SHELL, 1994. JOLENE RICKARD

have something to care about. Maybe what I see in a lot of people is that they don't care about what we have been given in this life. Sometimes we have to stand up intelligently. We have to realize that the days of taking, of frontal attacks or of the gun, are over. Our battles are very different, so how we strategize is significant.

On corn and community: Community is very specific for me. We have to be able to work together to continue growing corn. It is something other people have neither the knowledge of or the responsibility for. As I reach forty, I have to be able to know how to grow this. It is as simple as that. Understanding when to plant, the moon, the seasons, knowing how to feel it, look at it, touch it — working side by side with the people who know. You can't work together unless you enjoy it. I get immense pleasure from coming together with my family and our friends. We want the whole community to learn this, not just the community of Tuscarora. Our attitude is that you come and work with us. We are not interested in somebody who wants to mutate and hybridize the seeds. We want to keep the seeds going because they will feed our people for the next seven generations. The corn literally feeds us. At the same time, we can centre ourselves around it to feed us on the spiritual and cultural level. My Uncle Norton is a driving force. This is his mission, this what he does. We come together under his leadership to do this, and so it is good. I have had a lot of different experiences, and it has been a long journey to come home.

On the meaning of photography: The world is visual. How we begin to perceive, connect, and create associations with images is how we will understand the world. The images and thought patterns I am putting in place, their connections, are thought markers that I want our kids to be able to contemplate. I work in photography because it provides a moment of reflective pause. I am seduced by video, by the electronic media, by the "digital pulse." I am not claiming that it is a language, but I do think that it is a formation of knowledge. I feel what I am doing is trying to pull things together to form knowledge. It is not just for our children, it is for everybody. If we can get more people thinking in these terms it will be easier going. I would like to be as generous as possible with these ideas.

On symbols in art: My work is meaningful when people look at it because they are the ones who recognize the details. I feel Native people are my primary audience. They are an audience already familiar with the thoughts, symbols, and visual ideas I am working with. They are going to recognize them more readily. People trained in how

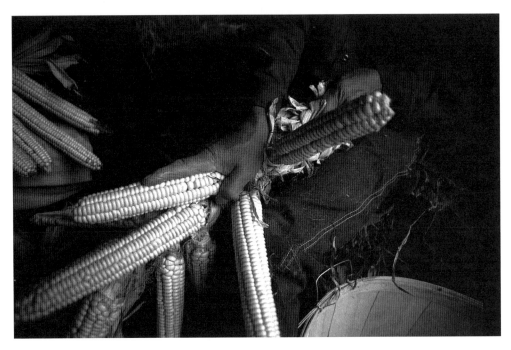

CRACKED SHELL, 1994. JOLENE RICKARD

to look at some of this work will recognize relationships on a formal level, then struggle with the meaning of symbols. So you have two different things going on for two different peoples. I see it as frustrating because I have had to learn all of the specifics of other cultures in order to move freely in the world. I want other people to take the responsibility of learning my symbols and thoughts. "Is this a farmer thing? Corn culture — what is that about? Orville Redenbacher Popcorn?" These are all the things that people come back at you with, you know, what we are faced with, and that is what putting this work out there does. Some people just don't want to deal with it. They want to deal with pop culture, to chew pop culture, to regurgitate pop culture, and to analyze pop culture. I bring other things to the table beyond what is considered pop culture. People ask, "What is that? Is it romantic, is it retro, is it derivative?"

On opening a dialogic space: We are at a point in Iroquoian society, in our relationships to both the US and Canadian governments, where they're wondering when we are going to let go of our borders. I need to do something that reconfirms our borders — the "borders of sovereignty" — the geopolitical borders that mark our nationhood, our reservation, our self-determination, and our territories. What I want to mark is the consciousness in people who are outside our experience that this is our homeland and it will never change. People in this part of the world have never dealt with that issue. How do we deal with it? How do we create that dialogue? How do we say to each other that there has to be an acknowledgment, that we have to speak of our territory in terms of "first nations"? How do we make that space of consciousness that we have to open up for our children? I do not yet know how to do it.

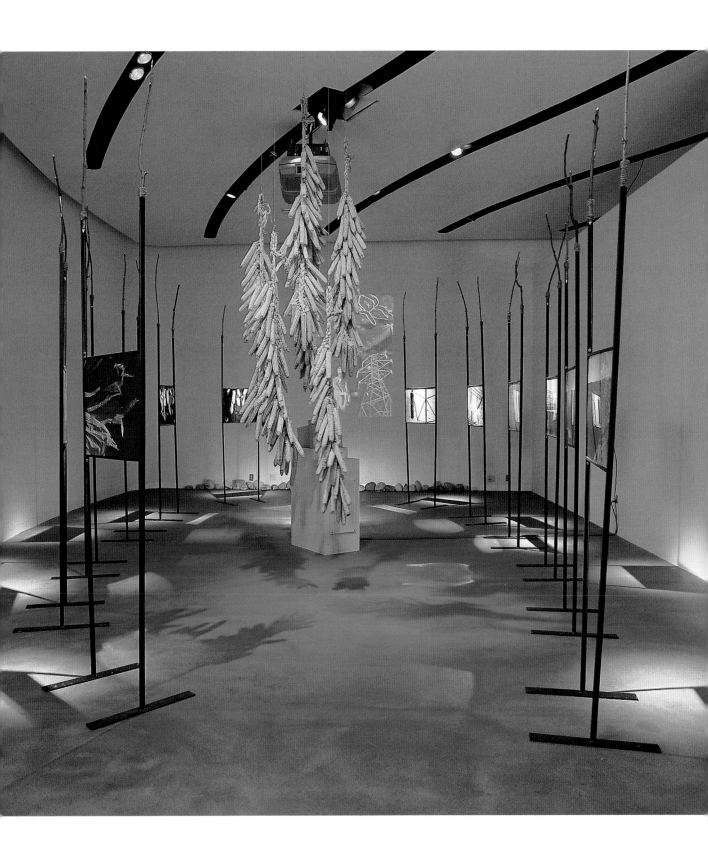

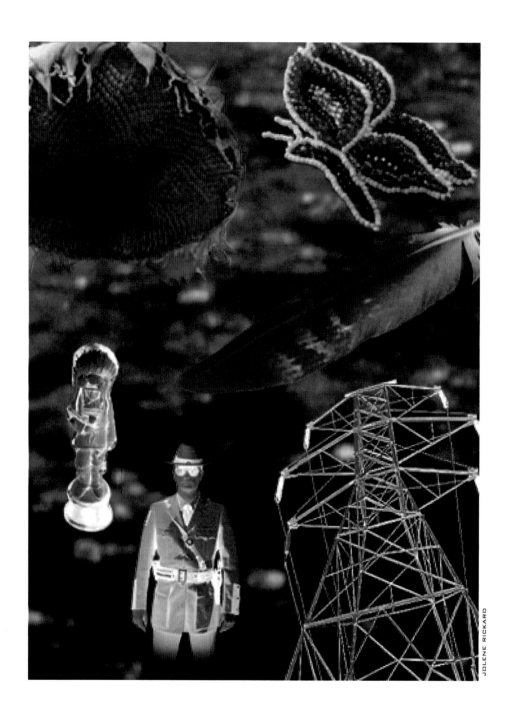

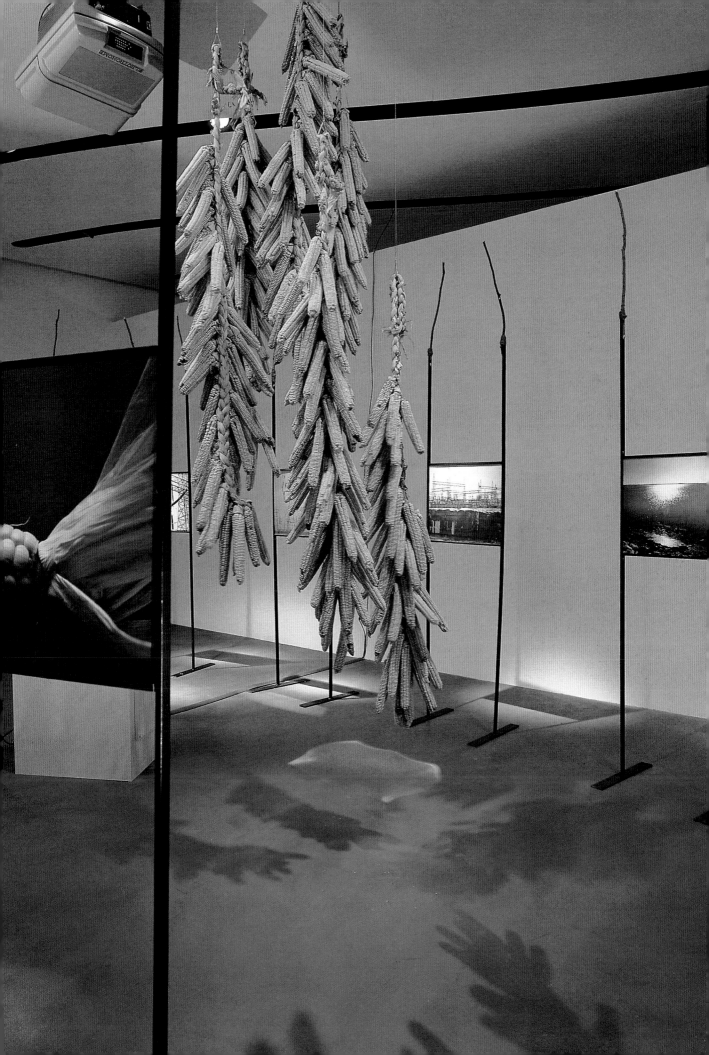

MATEO ROMERO

PAINTED CAVES

WHEN THUNDER BEING WOMAN LEFT ME, 1995. COURTESY OF MATEO
ROMERO

MATEO ROMERO: PAINTED CAVES

CONSPIRACY THEORY
NANCY MARIE MITHLO

> Is there a conspiracy to end authentic points of view, or is it just
> silence? Is there something like a deafening, stifling silence out
> there? I don't think there is a conspiracy. I think we do it to our-
> selves. We stop ourselves because we don't take it on ourselves
> to be responsible for creating conceptual spaces and educating
> people to support the work we want to do. There's not a lot of
> infrastructure. You have to create your own space.
> — Mateo Romero (interview, 1997)

Perhaps it's our generation — thirtysomethings who have enough confidence and
training to openly question the mandates of an over-zealous market, but who find
ourselves on a short rope when it comes to exposing the naiveté of our patrons lest we
find ourselves abandoned by the only transportation left. Too old to be overly opti-
mistic, too young to be crassly cynical, we tread boldly into uncharted territory without
the protection that age may afford and lacking a certain stupidity that might have been
charming ten years earlier. The choice to enter this no-man's-land of questioning
carries its own risks. Yet the alternative — mute victimhood — is much worse. The
conspiracy, real or imagined, loses all its force once you bypass the roadblocks and
chart your own path. Some artists never apprehend the journey, others embrace it. Of
the two extremes, Mateo Romero errs on the side of taking the long road home.

Romero's work reflects the passages that arise from a dedicated search for
truthful images. From his "pop culturalism" of the 1980s (better known by the "Coke
Can Fetish" titles) to the stormy *Tales of Ordinary Violence* series that marked his
completion of an MFA in 1996, Romero communicates the poignancy of contemporary
Native life. Alcoholism, violence, poverty, commercialization, loss of religion, loss of
family, and just plain loss are presented without apologies. Although his messages are
consistently oblique, this is not propaganda. Rather, he delivers information from the
perspective of an informed bystander. He places himself alongside the viewer —
neither higher nor lower nor any closer than the average interloper. Romero
instinctively understands that in our media-saturated society, one does not have to
form opinions for the audience — they have more than enough visual messages to
choose from — one needs only to have solid marks or gestures that inform. Head-on

collisions, whether with a non-Indian audience or his own Keresan community, are not his style.

Romero has described his paintings as "social landscapes" in which figurative elements blend and merge with abstract symbols. His poignant illustrations of personal episodes are skilfully executed in a style that evokes the immediacy and drama of the moment. The viewer is witness to some unsettling tragedy without the comfort afforded by a conclusion. The handling of the paint seems to mirror his approach to subject matter: the paint application is textural, laboured, and clearly manufactured. Strokes are highlighted, not muted; the starkness of lines helps to emphasize the gist behind the canvas, the attempt to show contemporary Native life in all its beauty and ugliness. Gambling and fast cars share equal time with adoration and portraiture. In *Indian Gaming*, the katchina heads depicted in the slot machine were viewed as controversial because of their reference to religious imagery. Romero painted the heads out and back in — right up to the opening of the exhibition *Chongo Brothers* at the Museum of Indian Arts and Culture, Santa Fe, in which the painting played a central role.

Romero chose to base his installation for *Reservation X* on the Painted Caves at Bandelier National Monument in northern New Mexico. "It's an amazing spot that functions in several ways. It's a living shrine because it's still in use. Forty feet up the cliff face, a ledge with an overhang comes in like a cross-section. Offerings of antlers and cornmeal are placed in different areas. One of the more interesting things about it is the incredible pictographic mural on the back." This curvilinear wall of pictographs charts a time sequence progressing from handprints to horses to script. Hunting ritual flows to churches and conquistadors, merging at the end to signed text and written records. This is an active place, a place Romero has visited, a place where his father and his grandfather might stop at night to make tortillas and talk over a fire. The painted cave signals both personal and community connections. While it is a location for individual creators to add their own messages, they make marks in a spirit of tribalness, with a sense of belonging to a larger group.

This potent spot of remembrance and affirmation provided Romero with the model for his installation.

There are four major themes to the work. One deals with a visual mapping of physical migrations that reads from a Pueblo-Indian

PAINTED CAVES, BANDELIER NATIONAL MONUMENT, NEW MEXICO. RUSS FINLEY

period to an urban setting. The spiritual migrations begin with a kiva setting and end with a Pojoaque Tewa Buffalo dance. The transportation theme incorporates walking, horses, and planes, trains, and automobiles. The final theme is mark-making, a reference to written text from simple hand prints to bar codes. The first half of the mural has nothing to do with European culture. These themes are really stories of our people.

As a painter who has worked successfully in mixed media, he decided to apply this conceptual idea of documentation to a photo mural with a temporal lineal progression from early Cochiti photographs to present-day photographs. By appropriating the painted caves code of interpretation, Romero signals his alignment with community as a force greater than himself. The intent of the mural as a medium has historically been to reach out to the public. Yet the use of photography inescapably defines his project as a modernist endeavour; the collective vision is collapsed under the individual who stages, frames, and shoots the capsule of time captured on film. Certainly viewers will visit this site in the semi-religious state of museum awe, yet none will settle down for the night, cook tortillas, and talk. In fact, it seems unavoidable to interpret the work as anything other than a feat of the individual imagination, despite the artist's intentions. The choice seems obvious; either play the game by the rules or stand outside the action, unnamed and unrecognized.

It wasn't always the case that Native producers felt the strain of representing themselves so acutely. The tension stems from a shift in which Native artists from the baby-boom generation were assumed to have a standing in their community, yet iden-

tity for the next generation was not so assured. The post-World War II era found our parents relocating to urban areas, striving to be the first generation to earn higher education degrees. "Professional Indian artist" as a formal role did not arrive on the scene until the early 1960s. This modern role of the idiosyncratic artist proved to be problematic for many tribal communities. According to Romero, "The concept of the artist who stands out is still a little bit foreign. There's anxiety about that."

Romero told me that he credits our lack of resolution about the correct role of an artist in a tribal community to a system of training for Native artists that reinforced colonialist ideas:

> By and large, the concept of artist is becoming part of the European art market. Like, the individual artist who breaks away from the crowd. It's acute. And that starts with the coming of the railroad, the Dunn school educational process, and the opening of a market place, the Indian Market. All these conscious policies that reinforce external pressures on a marketplace make it a necessity — not just a possibility, but a necessity — for Native artists to become very cynical, self-marketing people. Because they have to be even better. They have to become individuals.

This predicament feeds Romero's work in a fertile, self-exposing way. The viewer cannot see the negotiations behind the scenes. The process of creating art in a hyper-driven market economy while also remaining loyal to the collective thought of a community happens discretely. These crossroads stand like road markers in the development of an artist's career. What direction was taken? How do community standards feed the individual markings found in the Painted Caves? Was the individual work accepted or rejected?

It is at these intersections that the most interesting work is being pursued in contemporary Indian art. Romero's "just do it" philosophy leads him into the centre of the debate in an unconscious, almost intuitive way. Trial by fire may be his motto, yet even we, the viewers, are not fully aware of the risks one takes by transgressing ever so lightly on new ground. It is his willingness to walk into the centre that marks his genius. Silence will not be tolerated — all the confusion and pain of forming new roles is embraced, making his work unique among those who choose to stand mute or place the blame outside themselves. As a creator of the infrastructure needed to find new interpretations, Romero demonstrates a concern for the long run of contemporary Indian arts. His work seems to say, "Quit theorizing. Create your own space. Keep moving." The momentum is sure to provide answers somewhere along the way.

MATEO ROMERO SPEAKS . . .

On identity: I don't know what it's like to be an urban Indian. I was raised as an individual with my father as role model. I think it created a sensibility in me: "Look at what it is to be Indian." But there wasn't the sense of an extended social construct. I'm a bit of an outsider and an insider. I've lived with my people and in other village communities. At times I've been very active in village social and religious life. I approach my people from a sense of loving and being part of them, but I also have a different perspective because of having been raised in the San Francisco Bay area and my educational and artistic experiences. So I don't speak as a very orthodox, conservative, or traditional Cochiti. To quote James Luna, I call myself a "contemporary traditional."

On living in a pueblo: I like to visit the urban environment; I like the stimulation, the level of intensity, the activity, all that background noise. But I think my heart is more at peace in the quiet New Mexico setting. This is where I see myself raising my children. In my case, I had to re-identify with my people. I see my children having an opportunity to grow up in the middle of it, not having some of the questions I did when I was making that identification. I think the process is going to be different, in some ways more profound. My children have opportunities that I didn't have because of the way they are being raised.

On gaming and building community: In the *New Mexican*, a woman described us as a conquered people. She also said that Indian gaming is the end of our culture, the last gasp of Indian culture. I think the opposite is happening. We are not a conquered people. We are in conflict and we are acculturated with other cultures. What is going to let us live into the next century and grow? The fact that we can maintain some sense of traditionalism, history, community, and take opportunities like Indian gaming and integrate them. It is amazing how Indian gaming is used by some of the tribes. In San Juan, for instance, they use it to fund their Head Start program and Meals for Elders. Money is not going to come from the federal government, it is going to come from things like Indian gaming. It is completely non-capitalistic, almost socialistic. People criticize it and say that you are going to create victimization. In fact, the beauty of it is that the community is focused inward. It is taking money and putting it into such things as daycare.

TENT ROCKS, JEMEZ MOUNTAINS, NEW MEXICO. LAWRENCE PARENT

On building for the future: Our strength is that we can maintain the sensibility of the past and still be in the present. We can build corporate infrastructures and continue to live where our shrines were hundreds of years ago and still dance with children in the village. That is the beauty of it! That is the lyricism of it! There is no understanding of Indian people who are leaning more toward a corporate infrastructure. It is considered materialistic, a turning away from our ancestors and our myths. But it isn't capitalism as I understand it; it is something altogether different. It is growing!

On community identity: It is very important for my children They have so many things I didn't grow up with. It is difficult to be older and to have to reidentify with things that a child would normally be exposed to. I am trying to move closer to some of the things that are going on in the pueblo in terms of dancing and community.

On community: I do not see community as utopian. I see it as a frail and treacherous construct that almost doesn't work because of its human essence and weakness. Yet in its frailty there is beauty, there is the ability to survive. I see it as almost an impossibility that people can come together and still be focused. I use the metaphor for being focused almost as an impossibility. But it is there, very much there.

EXTERIOR OF A HOME AT COCHITI PUEBLO. F. STARR COLLECTION, 1894-1910, NMAI (15743)

On the Pueblo culture: I am Southern Keresan and a member of the Cochiti Pueblo. We are descendants of the Anasazi peoples, who inhabited the Rio Grande area for thousands of years. Before the reservation site was established and before the Spanish intrusion, we lived in an area called Bandelier, where the Bandelier National Monument is now. Much of our culture has been based on living together. We are agrarian: we plant corn, beans, squash, and melons. We're noted for our ceramics and textiles. These are some of the values that come out of the community.

On developing an aesthetic: When I started working it was very much the Cochiti Nation and myself. It was a cathartic experience. Coming back to my own village and trying to figure out where I fit was important for me as an artist and as part of this living culture. I would have to say there is a Cochiti aesthetic at work in my painting. Maybe it is a nuance. Maybe it is more of an emotional thing, a search for the self and how I fit in. A lot of what I am trying to deal with has to do with some kind of early transgressive or marginal experience. I do not take a position where they call me a painter first and an Indian second. I am very much an Indian artist. I am very much a Cochiti Pueblo person.

On being critical: There is a basis of formalism in the way that I use colour and line. I try to bring a critique or dialogue into the paintings I do. I try to have a subversive critique for people to see. To do work that hits the market does not give you a chance to be critical or to examine things. It is not challenging. I think that if you are critical, the art is better.

LEFT: CHARDÉ ROMERO, COCHITI PUEBLO FEAST DAY. MATEO ROMERO

BELOW: DIEGO ROMERO AND JAMES PECOS, COCHITI PUEBLO FEAST DAY. MATEO ROMERO

On *Painted Caves*: It is about the past, about connection, and about a sense of my community. In particular, it is about my family — my grandparents, my father, and myself. This structural narrative is very closely modelled after the Painted Caves Shrine in Bandelier National Monument. Historically, it has been used by our people for thousands of years as a place of prayer and a place to record the passage of time and events. In the mural, I'm taking images and making a chronological narrative about my family, and in particular our people. Hopefully, these issues reach a larger audience and go beyond saying, "This is how the Anasazi record information." Hopefully, the work touches the human condition, so that people can access that information and say, "There's something about the way this works visually that is interesting." This is my goal. Basing the *Painted Caves* mural on family is also a way of creating a space where I can talk about personal, community, and family issues.

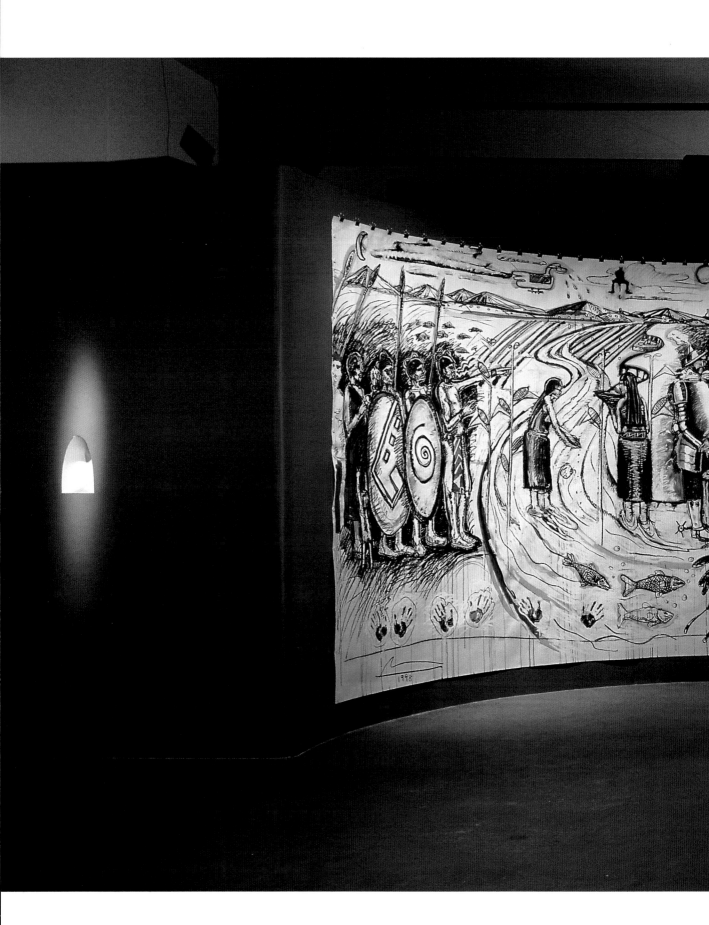

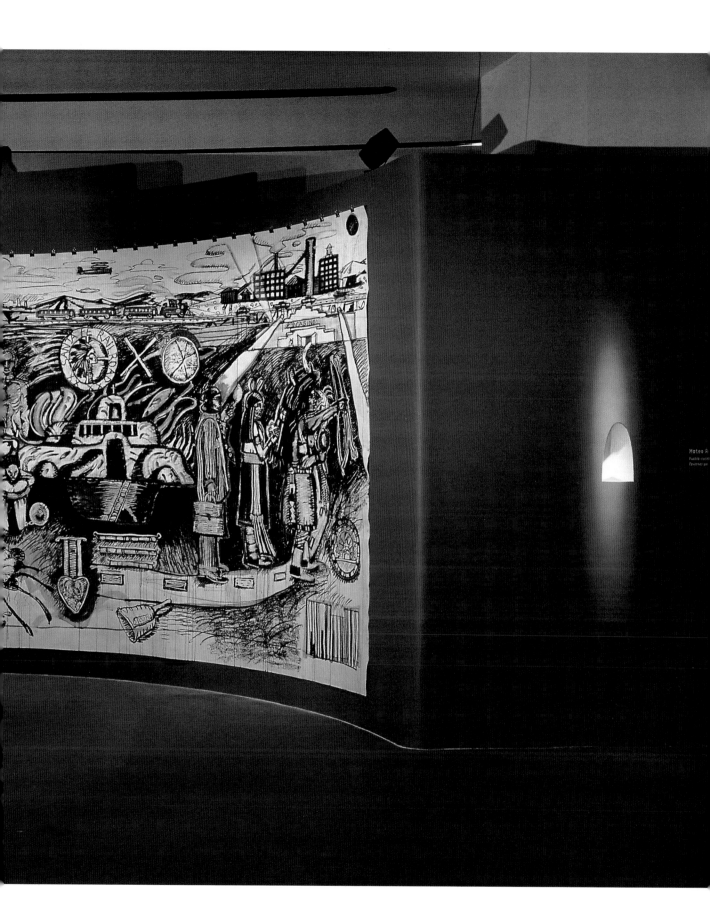

C. MAXX STEVENS
IF THESE WALLS COULD TALK

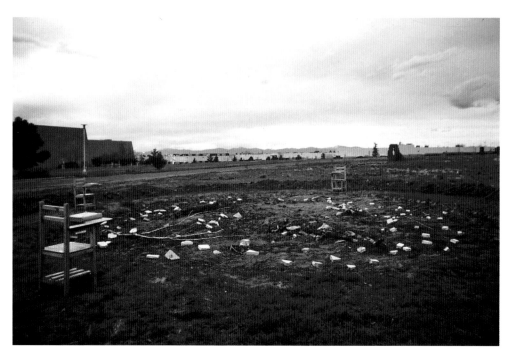

HISTORY: TRUE OR FALSE. COURTESY OF C. MAXX STEVENS

C. MAXX STEVENS: IF THESE WALLS
COULD TALK

ENVIRONMENTS THAT TELL STORIES
GERALD McMASTER

C. Maxx Stevens was born in Wewoka, Oklahoma, which is part of the Seminole Nation region, and grew up in Wichita, Kansas. Educated at Haskell Indian Junior College in Lawrence and at the State University and the United Welding Institute in Wichita, she completed an MFA at Indiana University in Bloomington. She currently teaches at the Rhode Island School of Design in Providence. In the late 1980s she worked as a theatrical artisan for Wichita's Music Theater, where she gained the knowledge and experience she would later use to create installations. I call her work "self-portraiture" because of several motivating and personal themes that are critical to understanding her current installation, *if these walls could talk*.

The name Seminole comes from the Spanish *cimarrones*, meaning "savages or runaway slaves" (or from the Creek *semanoli*). The use of the word is ironic, since many Seminoles had resisted slavery and fought a war of attrition against foreign invaders. During the early nineteenth century, the Five Civilized Tribes — the Cherokee, Creek, Chickasaw, Choctaw, and Seminole — were forcibly removed from their land because of the burgeoning cotton industry. As a result of the Indian Removal Act 1830, they were all forced to walk a thousand miles over the infamous Trail of Tears, from the southeast to an area once known as Indian Territory, now the state of Oklahoma. A large division of Seminoles moved in 1836, but the ancestors of the present-day Florida Seminoles managed to conceal themselves in the Everglades and thus avoid the tragedy of their Oklahoma relatives.

The second and third major disruptions to Seminole communities were the systematic removal of children to educational facilities known as boarding schools and the assimilationist program that affected entire families. The intent of the boarding school was to remove children from their families in the hope that it would be easier to eradicate Indian culture from them than from adults. They were taken en masse from their homes and sent to military-style schools, far from home, family, and community. In the 1950s, a second wave of dislocation occurred, when massive numbers of Indian people were compelled to move to large American cities. The United States government thought that taking them away from the land would turn them into useful, hard-working citizens. It was believed that Indian people were not making good use of their land because they were leasing it to non-Indian people instead of using it them-

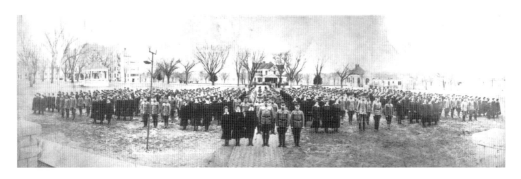

HASKELL INSTITUTE, C. 1921. ESTABLISHED IN 1884 AS AN OFF-RESERVATION MANUAL LABOUR BOARDING SCHOOL, COMPLETE WITH MILITARY-LIKE DISCIPLINE, THE HASKELL IN-STITUTE BECAME A TWO-YEAR TECHNICAL COLLEGE FOR SELECT INDIANS IN THE LATE 1930s. BY 1970, IT HAD CHANGED ITS NAME TO HASKELL INDIAN JUNIOR COLLEGE. MORE RECENTLY, IT BECAME THE FIRST INDIAN UNIVERSITY IN THE UNITED STATES, HASKELL INDIAN NATIONS UNIVERSITY. COURTESY OF HASKELL INDIAN NATIONS UNIVERSITY

selves. The Indian Relocation Act 1956 affected many families, among them the Stevens family, who had already moved to Wichita in 1954, just before the migration. Many Indian families who moved to the city were poorly equipped for urban living, yet some managed to find work. Those in Wichita, for instance, survived by building airplanes for the government.

Stevens has drawn on these themes over the past several years. An earlier work, *Dreaming of Circles and Chairs*, dealt with the issue of community identity. The artist describes what it is like to grow up in a city with very little sense of community. The closed space in the work provides protection from the unknown, and the chairs set up in a defensive manner guard one's vulnerability. Stevens asks, "If you're urban, are you Indian? If you're not, what are you?" Rhetorical questions, yet they gnaw away at the self, placing it in a position of otherness by questioning authenticity.

In a later work, *History: True or False*, an exterior installation, Stevens used old school chairs in a circular arrangement around an quasi-excavation. In this work the chairs no longer sit like muskox, but gaze inward at a central excavation pit containing an installation of stones and figures in various stages of fragmentation and decom-position. The institutional character of the surrounding desk chairs informs us of the power and authority of the establishment's text, whose truth is unassailable. The words "History," "True," "Or," "False" were written in the books on each desk. The suggestion is that history has only right or wrong answers, depending on who is writing, that the defeated are always defenceless, and that their stories eventually disappear and become forgotten.

Fragments of Life, the most poignant piece in this series, reflects the despair aboriginal people faced when they moved to cities in the 1950s and 1960s. Stevens addresses issues of her historical, tribal, and urban identity, all adding up to multiple personas. The poetic and narrative-like words "Fighting" and "Surviving in Cities" describe the condition of "Urban Indian." A photograph of a city and floating houses suggest the disharmony of urban living. The work is an unapologetic look at Stevens's life as a modern urban Seminole woman.

Although Stevens's work is "self-portraiture," it is not so in the traditional sense; rather, she layers each piece with signs from her life. She says that her commitment is to "creating sculptural environments that tell stories about history, the present state, and our hope in the future." She describes herself as an "unspeaking visual storyteller," a practice that was influenced by her father, who often told stories of the history and culture of the Seminole nation. She credits him as a great influence on her later work, particularly the practice of storytelling.

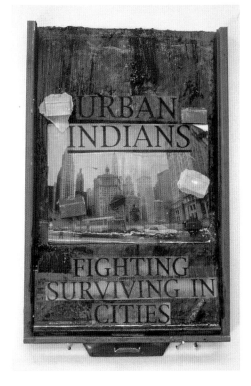

Stevens teaches in art schools, and she takes these responsibilities very seriously. Although her work occurs within institutional frameworks, her strategy is not so much to convince her students as to inform them of alternative ways of seeing. She frequently advises them to "listen to the crows . . . watch the winds . . . listen to the elders . . . watch for signs . . . honour their past and themselves." For Stevens, crows are a sign of self-reflection because, like her, they move everywhere, and are therefore an important part of her life. She considers them messengers.

Stevens's installation *if these walls could talk* is a story of educational systems and the survival of community, of maintaining a sense of Seminole-ness in the modern world. This work addresses discordant, contradictory, and confusing messages. The installation is divided in two: on one side are school desks overlaid with books, on the other side is a long table topped with onions, a reference to harvesting, and a radio playing the voice of the artist's mother at one end. In the school section, the perimeter walls are embedded with approximately twenty speakers that continuously play the stories of her former students.

if these walls could talk combines all the thematic elements previously outlined — Seminole and family history, education, storytelling, and community. The work asks the question, How does one live in two worlds? This may seem like a simple, reductivist framework, but the idea is more complex. Stevens asked students from

Haskell and the Institute of American Indian Arts, as well as several friends, to tell her their stories. She took those stories and animated them in the installation by embedding them in the wall. The listener hears voices talking about education and community, with an underlying subtext of identity. At first this divided piece may seem like a dichotomy: good/bad, positive/negative. It is an empowering work, however, showing both Stevens's love of her family and community and a pedagogical commitment to students. Somehow the talking walls have greater secrets than the open-air setting, where everyone participates in a common activity and where secrets are vulnerable. The total work is life-sustaining, not life-threatening.

On one of the classroom chairs sits a cinnamon roll. Stevens explains, "At the beginning of every year, I would always get kind of nervous and scared. I got up one time and said, 'Hi, I'm Maxx and I'm a cinnamon roll.'" The humour, of course, stems from Stevens's nervous attempt to pronounce the name of her tribe, the Seminole. The name becomes a personal buffer as a protection from malice. Through humour, she takes back control of the naming, unlike her people, who were named and thus controlled. In a formal context, the mistake is embarrassing, but in the communal context, an Oklahoma sensibility would laugh with Maxx, not at her. The onions on the other side of the room would undoubtedly make everyone cry, then laugh together. In the classroom, the gaffe would make her cry while everyone laughed. Stevens sums up the situation: "Being an urban Indian has always been a source of dualism in my work, and that sometimes gives the viewer a sense of the conflict it generates."

C. MAXX STEVENS SPEAKS . . .

On growing up: I think of myself as coming from two places. I was born in Wewoka, Oklahoma, but I was educated in Wichita, Kansas. I had a strong connection to Oklahoma because I would go there in the summer. I always remember the Oklahoma summers, partly because of my Aunt Nellie. She was my favourite aunt and an important member of the family and tribe.

I grew up in an area of Wichita called Plainview, where different tribes from all over the country came to work at one of the airplane plants. I attended public schools but wanted to go to an Indian school because my mom and dad would talk about their experience in Chilacho. They wouldn't allow me to go there, so after I graduated I decided to go to Haskell Indian Junior College. At Haskell everyone was from different regions and reservations. I was an urban Indian. At first, students would beat me up, but after they got to know me, they decided I was okay. I hung out with a funny group, most of them Plains Indians who were urban Indians. My experience at Haskell was a turning point for me.

On home: My home is wherever I move. Because I'm a teacher, I move a lot. Back home is two places: Wichita, where two of my sisters live, and Wewoka, where my mom lives.

On identity: When I first went to Haskell, Dr. Richard West said, "Know your own culture. Know who you are. Don't do the kind of generic Indian art that's taken from different tribes. Look at who you are." That stuck with me. So when I talk to my students, I always like them to look at who they are and where they're from. Tribal history needs to be carried on. I tell them they need to look everywhere to appreciate our diversity as people, not just within their own tribe. But they also have to maintain themselves. If you have that strength of holding on to who you are, you can do anything.

On maintaining an Indian identity: It's more like maintaining, advancing, and surviving. We lost a lot in the past, but we can preserve what we have in ourselves. I look at the students, at myself, and at the Native communities. We're surviving, trying to keep what we have. I like to talk about language, culture, and philosophies with the students and hear them share their experiences. Sometimes they get really emotional. Sometimes their stories are really funny. It's good that they talk. I think that keeps it alive for them.

LEFT: WILL ROGERS ELEMENTARY SCHOOL, PLAINVIEW, KANSAS. "ALL THE SCHOOLS BUILT WERE TORN DOWN; ALL THAT REMAINS ARE THESE FRAGMENTS." HENRY NELSON

BELOW: MAXX STEVENS'S CHILDHOOD HOME IN PLAINVIEW, KANSAS. HENRY NELSON

On identity and the rez: Some of my students are searching for their identity. Even though their parents are from the rez, they didn't go to school or live on the rez. But when they get here they say, "Yes, I'm from such and such rez." Being from a rez is their *ideal* identity, and they seem to try to hook on to the idea that if they are from a rez, then their identity is more valid.

On the importance of having Indian blood: It was more of an issue in Native arts several years ago because of the Indian Arts and Crafts Act 1990. To exhibit as an Indian in a museum or gallery show, you had to have a CIB [Certificate of Indian Blood] card to prove you were an Indian. Some Indian people were excluded because their ancestors refused to be registered by the government. When scholarships came up, students knew they had to have their CIB card to be considered. Here the CIB card makes someone more elite as a Native person. I don't really believe in the card as telling the whole story, but I know in some ways it's necessary. It creates an odd conflict in me.

On Indian education: I'm interested in our Native students' education — how is it going to affect us later, how is it going to help us, how will it hurt us? These are always questions in the Seminole community, because they don't really believe in education. I was one of the few who went on to higher education. These days the Seminoles are seeing that education is needed, so many are going on in their education. That's a good change for the tribe. Because of my experience of having attended public schools and a BIA school, I can see both sides. Education breaks up communities, especially in the old days when people were forced to go to boarding schools. But I can also see that traditional and contemporary education is important for the tribe's survival.

On her traditional community: When I go home I see how we have maintained tribal existence, like continuing sacred ceremonies. In Oklahoma, certain ceremonies

like the Stomp Dance and the Green Corn Dance were banned by the government. The new tradition is to dance late at night up in the hills. You park your car out on the dirt road and hike up through the twigs, trees, and bushes. Finally, you get there. There is a fire in the middle and everyone sits around it. You sit in your clan section and watch people dance, then you participate. Green Corn Dances go on all night long, then during the day, games and women's dances. It's very beautiful to be part of that community and feel hidden from the world. It's like holding on to something very precious and important.

On teaching installation art: I try keeping the language of the materials basic, common objects like dirt, feathers, books, jackets, using them metaphorically to work with the concepts of the piece. By working that way, Native people from both reservations and cities as well as non-Natives can understand what I'm trying to say. I manipulate the materials so there is a layering of concepts, which becomes the final message. When I came to the Institute of American Indian Arts, I thought everyone knew what installation art was. I soon found out they didn't. Between what Char Teters and I were teaching them, they started understanding how they could use the land as part of their format. I'd tell them that they needed to work in galleries or alternative spaces for the experience of seeing how different art pieces are put together. I tried to educate them about forms of installations — how to view them, how to think about them — and once they got initiated to the concepts of materials, space, and scale, they began to see how they could layer concepts and materials.

On her installation: My piece, *if these walls could talk*, is about stories coming out of walls. I introduce myself as C. Maxx Stevens, a Seminole from the Oklahoma region. I'm making a classroom situation, a long room divided up into two sections. "My name is Maxx" is written on the blackboard. I set up desks with books on them that contain my family history. As you walk by the walls, you catch sounds of people telling their stories. Different stories going on at the same time. You catch one person's voice, and then you walk on and catch another. On the other side will be a long table with onions on top. In this area, I'd like to have the stories I've always heard during eating time or when I'm serving people. I want to build a contrast between the stories of people and going to BIA schools — how they feel about education today and what's being lost. It will be layered with people's thoughts. Conceptually, the piece is community based.

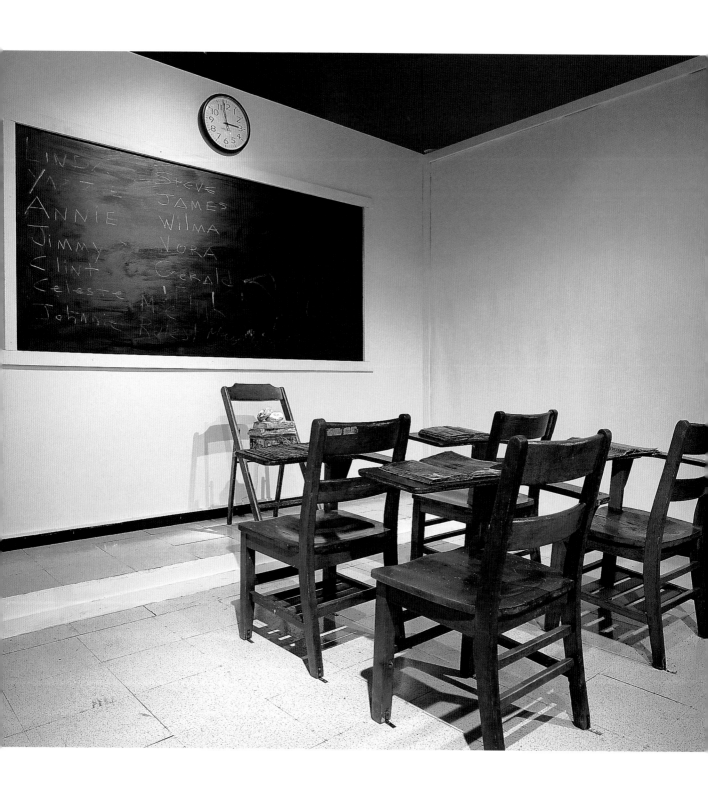

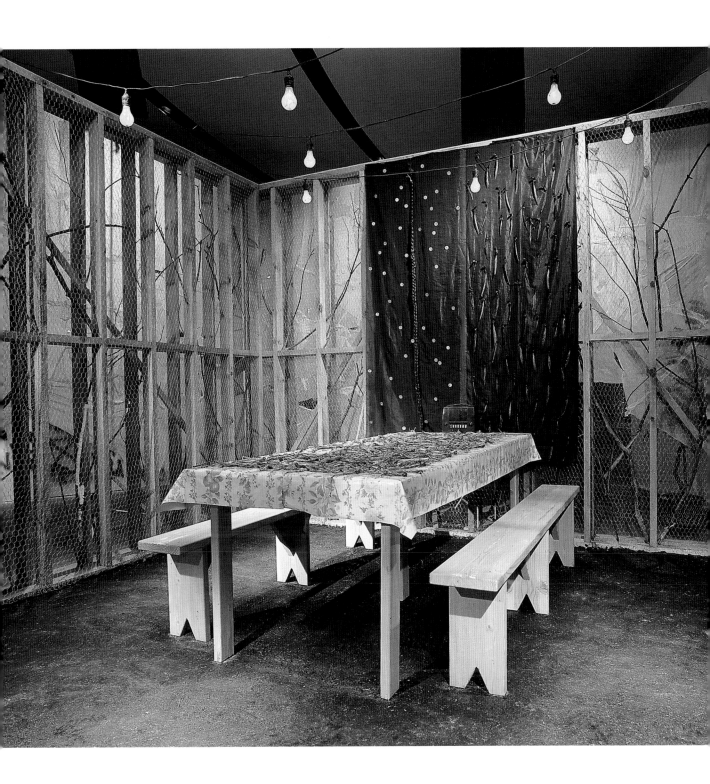

SELECTED REFERENCES

Alexie, Sherman. *Reservation Blues*. New York: Warner Books, 1995.

Atwood, Margaret. *Survival: A Thematic Guide to Canadian Literature*. Toronto: House of Anansi, 1972.

Becker, Howard Saul. *Art Worlds*. Berkeley: University of California Press, 1982.

Bryson, Norman. "The Commonplace Look." *Times Literary Supplement*, 17 October 1997, 20-21.

Cardinal, Harold. *The Unjust Society: The Tragedy of Canada's Indians*. Edmonton: Hurtig, 1969.

Crosby, Marcia. "Nations in Urban Landscapes." In *Nations in Urban Landscapes: Faye HeavyShield, Shelley Niro, Eric Robertson*. Vancouver: Contemporary Art Gallery, 1996.

Doxtater, Deborah, et al. *Revisions*. Banff AB: Walter Phillips Gallery, 1992.

Eco, Umberto. *Travels in Hyperreality*. Orlando FL: Harcourt Brace, 1986.

Funk, Jack, and Gordon Lobe. . . . *And They Told Us Their Stories: A Book of Indian Stories*. Saskatoon: Saskatoon District Tribal Council, 1991.

Goldie, Terry. *Fear and Temptation: The Image of the Indigene in Canadian, Australian, and New Zealand Literatures*. Kingston ON: Queen's University Press, 1989.

Hobson, Geary. "Remembering the Earth." In *The Remembered Earth: An Anthology of Contemporary Native American Literature*. Albuquerque: University of New Mexico Press, 1981.

Lévi-Strauss, Claude. "The Art of the Northwest Coast at the American Museum of Natural History." *Gazette des Beaux-Arts*, quoted in *La voie des masques*, translated by Sylvia Modelski. Geneva: Albert Skira, 1975.

Lévi-Strauss, Claude. "Saudades do Brasil," translated by Sylvia Modelski. *New York Review of Books*, 21 December 1995, 19-21.

Lynes, Barbara Buhler. *O'Keeffe, Stieglitz and the Critics, 1916-1929*. Chicago: University of Chicago Press, 1991.

McEvilley, Thomas. *Art and Otherness: Crisis in Cultural Identity*. Kingston NY: McPherson, 1992.

McMaster, Gerald. "Border Zones: The 'Injun-uity' of Aesthetic Tricks." *Cultural Studies* 9:1 (1995): 74-90.

Macnair, Peter L., et al. *The Legacy: Continuing Traditions of Canadian Northwest Coast Indian Art*. Victoria: British Columbia Provincial Museum, 1980.

MacNeil, William A. "Long Wait Rewarded, Visitors, Sponsors Say." *Albuquerque Journal* (North edition), 18 July 1997.

Miller, Daniel. "Primitive Art and the Necessity of Primitivism to Art." In *The Myth of Primitivism: Perspectives on Art*, edited by Susan Hiller. London: Routledge, 1991

Mitchell, Nancy [Mithlo]. *Art in America* 81 (1993), 23.

Navarro, Bruno. "Abiquiu's Fame Sparks Admiration and Resentment. The Georgia O'Keeffe Museum." *Santa Fe New Mexican* (special supplement), 13 July 1997.

Senaldi, Marco. "Michel Maffesoli: Sociologist, the Sorbonne." *Flash Art* 177 (summer 1994), 59-60.

Sharpe, Tom. "Get Georgia Off My Mind." *Albuquerque Journal*, 18 July 1997.

Soja, Edward W. *Thirdspace: Journeys to Los Angeles and Other Real and Imagined Places*. Cambridge: Blackwell Publishers, 1996.

Thomas, Nicholas. *Entangled Objects: Exchange, Material Culture and Colonialism in the Pacific*. Cambridge: Harvard University Press, 1991.

Todd, Loretta. "Notes on Appropriation." *Parallelogramme* 15:1 (1990): 30-31.

Todd, Loretta. "What More Do They Want?" In *Indigena: Contemporary Native Perspectives*, edited by Gerald McMaster and Lee-Ann Martin. Vancouver: Douglas & McIntyre, 1992.

Watchful Eyes. Phoenix AZ: Heard Museum, 1994.

Whitney, Kay. "Doubling Back." *Sculpture*, 7 April 1997, 28-31.

Wolff, Janet. *The Social Production of Art*. London: Macmillan, 1981.

CONTRIBUTORS

Paul Chaat Smith, a member of the Comanche tribe of Oklahoma, currently lives in Washington DC. A writer, critic, and curator, his most recent book, *Like a Hurricane: The Indian Movement from Alcatraz to Wounded Knee*, was written with Robert Allen Warrior. He has also written for film and television.

Gerald McMaster is Plains Cree. An artist, writer, and curator of Contemporary Indian Art at the Canadian Museum of Civilization, he has curated numerous exhibitions, most recently *Edward Poitras: Canada XLVI Biennale di Venezia* (1995). He is completing a doctoral dissertation at the Amsterdam School of Cultural Analysis, Theory and Interpretation.

Nancy Marie Mithlo, a member of the Fort Sill Chiricahua Warm Springs Apache Tribe, earned her PhD in cultural anthropology at Stanford University. A professor of museum studies at the Institute of American Indian Arts, she also teaches at the University of New Mexico and Santa Fe Community College. Her published essays include "History Is Dangerous" and "Demonstrations of Culture: Charlene Teters, the Rosa Parks of Campus Racism." She is currently researching the ideology of Indian beauty pageants.

Charlotte Townsend-Gault, an assistant professor of art history at the University of British Columbia, has published extensively on contemporary First Nations art in North America. She is at present writing a critical study of Northwest Coast art (an extension of her doctoral thesis from University College, London), entitled *Re-thinking Kwakiutl Food Vessels*. In 1992 she was co-curator of *Land Spirit Power: First Nations Artists at the National Gallery of Canada*.

INDEX TO ILLUSTRATIONS

This book was designed and typeset by Julie Scriver
of Goose Lane Editions in Fredericton, New Brunswick.
Colour separations and printing furnished by Friesens of Altona, Manitoba.

Typeset in Bodoni Book and Bank Gothic.
Printed on 100 lb. Luna Matte.